IMAGES
*of America*

# GRAND COULEE DAM

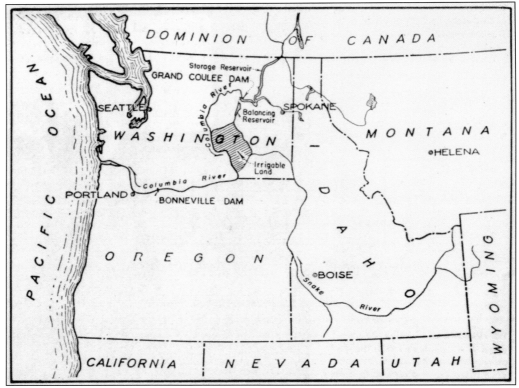

This map shows the main elements of the Columbia Basin Project. The Columbia River, originating in Canada and flowing southward across eastern Washington and then westward to the Pacific Ocean, is the source of both the hydroelectric power and irrigation water provided by the Columbia Basin Project. The Grand Coulee, an ancient channel that carried the Columbia River during Ice Age floods, is the location of the balancing reservoir shown on this map. Grand Coulee Dam is located on the Columbia River at the Grand Coulee, allowing water to be pumped from the Columbia River into the balancing reservoir, from which it is supplied by gravity-fed canals to the area shown on the map as irrigable land. The project was to provide water for 1,200,000 acres, but the actual irrigated acreage has been reported in the range of 550,000 to 700,000 acres. The storage reservoir shown on this map is known as Lake Roosevelt today and extends for 151 miles toward the United States–Canada border. (Courtesy author.)

ON THE COVER: A family enjoys the view of the world's largest concrete structure and largest power plant upon its completion from a point overlooking Grand Coulee Dam. Construction of the dam provided work for over 10,000 workers during the Great Depression and then contributed to the United States' victory in World War II by providing electric power for production of aluminum for aircraft, shipbuilding, production of atomic weapons at the Hanford Works that was established about 130 miles south of the dam, and much more. The dam was built at a cost of more than $163 million and the lives of at least 72 workers. The dam is a monument to the dream of visionaries who persevered against overwhelming opposition, to Pres. Franklin D. Roosevelt, to the efforts and sacrifices of those who built it, and to American initiative and ingenuity. (Courtesy Washington State Archives.)

IMAGES
*of America*

# GRAND COULEE
# DAM

Ray Bottenberg

ARCADIA
PUBLISHING

Published by Arcadia Publishing
Charleston, South Carolina

Printed in the United States of America

Library of Congress Catalog Card Number: 2007935830

For all general information contact Arcadia Publishing at:
Telephone 843-853-2070
Fax 843-853-0044
E-mail sales@arcadiapublishing.com
For customer service and orders:
Toll-Free 1-888-313-2665

Visit us on the Internet at www.arcadiapublishing.com

*For Ray Hobson, my friend and my mentor for this project,
who worked for Mason, Walsh, Atkinson, and Kier
Company on Grand Coulee Dam from the spring of 1936
through February 1937 to earn money for college.*

# CONTENTS

# ACKNOWLEDGMENTS

I wish to thank the Washington State Archives in Olympia, Washington; the National Archives in Denver, Colorado; the Bureau of Reclamation in Boise, Idaho; and Ray Hobson, Michael Fairley, and Julie Albright for making photographs available for use in this volume. It should be noted that some of the materials from the author's collection were originally published by the Bureau of Reclamation.

And I would also like to thank the following individuals for the guidance and assistance they have provided that made this volume possible: Ray Hobson, Chris Leedham, Gene Bowers, Mary Hammer of the Washington State Archives, Eric Bittner of the National Archives, Diana Cross and David Walsh of the Bureau of Reclamation, and Julie Albright, my editor at Arcadia Publishing.

# INTRODUCTION

The Grand Coulee in central Washington State is a massive channel created during the Pleistocene Epoch, or Ice Age, by the scouring action of retreating ice sheets and erosion caused by gigantic floods from melting glaciers. The Grand Coulee carried the Columbia River past the Big Bend area during several Ice Age periods when ice dams clogged the main channel. When the Grand Coulee carried the river, Steamboat Rock became an island 2 miles wide, between 800-foot-high waterfalls each 2 miles wide, and numerous other large waterfalls, such as the 400-foot-high Dry Falls, became active. With the end of the Ice Ages, about 15,000 years ago, the river returned to its regular channel, leaving the Grand Coulee dry.

Settlement of the area near the Grand Coulee began in 1859, proceeding at a slow pace until the 1880s when Coulee City was established and the Northern Pacific Railroad was built across the Columbia Basin. Settlers in the 1880s acquired their land for free under the Timber Culture Act of 1873 or at $1.25 per acre under the Desert Land Act of 1877. The settlers in the Columbia Basin found some of the land well suited for growing dry-land wheat, and an economy developed based upon wheat farming, sheep and cattle ranching, and mining.

The fact that the Grand Coulee was an ideal place to store irrigation water for the Columbia Basin did not go unnoticed for long. In 1892, both the *Coulee City News* and the *Spokane Spokesman* advocated irrigating the Columbia Basin with water diverted by a very high dam from the Columbia River into the Grand Coulee. By 1903, the U.S. Reclamation Service was aware of the possibilities of the site. Engineer Frederick Newell, chief of the Hydrographic Branch of the Geological Survey, visited and declared that "some day it will be built. But the time is not ripe right now. This will be the next big thing after the Panama Canal."

Opposition to a dam at the Grand Coulee began early, with the main opponents being Spokane private power interests including the Washington Water Power Company and many of Spokane's businesses. They offered the "gravity plan" as the most feasible way to irrigate the Columbia Basin, by way of a canal from the Pend Oreille River or the Spokane River. The gravity plan was first suggested by Elbert F. Blaine in 1917, and its supporters probably influenced a 1920 report by the Columbia Basin Survey Commission that labeled a dam at Grand Coulee "infeasible." On June 30, 1921, the Washington Water Power Company filed papers to build a dam 110 miles upstream from Grand Coulee at Kettle Falls, attempting to limit the height of any future dam at Grand Coulee, and formed the Columbia Basin Irrigation League in 1922. In the late 1920s and early 1930s, the gravity plan supporters were assisted by private power supporters from around the country when the debate between public and private power became a national one. Prominent gravity plan supporters in the 1920s included James E. McGovern, Elbert Blaine, Washington Water Power Company, Roy Gill, James A. Ford, Fred Adams, Gov. Ernest Lister, state geologist Henry Landes, the Spokane Chamber of Commerce, the Columbia Basin Irrigation League, and U.S. senator Clarence C. Dill.

Public support for a dam at the Grand Coulee began in earnest in 1918, when Ephrata attorney Billy Clapp suggested a dam on the Columbia River just downstream of the Grand Coulee to back up water into the coulee, much as the ancient ice dams had done, to provide a source of irrigation water for the Columbia Basin. Rufus Woods, publisher of the *Wenatchee Daily World*, seized upon Clapp's idea and made it the headline story in his July 18, 1918, edition. To back up water into the Grand Coulee would require a dam more than 600 feet high, which would back up water well into Canada more than 150 miles upstream, in violation of treaties with Canada.

The audacity of the idea prompted Superior Court judge R. S. Steiner at Waterville to exclaim, "Dam the Columbia! Verily, Baron Munchausen, thou art a piker." Ole J. Kallstead, a carpenter from the Washington city of Olympia, suggested a lower dam around 350 to 400 feet high, with pumps to move water into the Grand Coulee, thereby originating the "pumping plan." Prominent supporters of the pumping plan during the Roosevelt administration included James O'Sullivan; Billy Clapp; Rufus Woods; David R. McGinnis; Nathaniel "Nat" Washington, who drowned in the Columbia River near Grand Coulee; state Grange leader Albert Goss; the Columbia River Development League; Willis Batcheller, and U.S. senator Clarence C. Dill.

In 1920, the Reclamation Board of Review criticized the negative Columbia Basin Survey Commission report and recommended $50,000 worth of foundation exploration drilling. This drilling was accomplished by the International Diamond Drill Company of Spokane in 1922. Initial reports indicated a "flimsy foundation of soft rock," and "no rock has been encountered." After protests by pumping plan advocates, it was revealed that granite was actually encountered at depths of 172 feet, 157 feet, and even 62 feet below river level.

In 1922, Willis Batcheller was fired by the state Department of Conservation and Development for studying the Grand Coulee site rather than another site at Foster Creek. Batcheller smuggled out a draft of his report that showed the pumping plan was much more economical than the gravity plan even without any sales of electrical power.

Spokane private power interests responded to these developments by hiring as a consultant Maj. Gen. George W. Goethals, who, at age 64, had recently finished the Panama Canal and had an international reputation. He spent 10 days in the area during February 1922, after which he produced a report recommending the gravity plan and collected his $20,000 fee.

In 1928, Maj. John S. Butler of the Army Corps of Engineers was assigned to investigate the possibilities for power development on the Columbia River above the Snake River. Foundation exploration drilling commenced in August 1929. After several years of competition between the Corps of Engineers and the Bureau of Reclamation, Major Butler's 1,845-page report was released on March 29, 1932, with endorsements by the Bureau of Reclamation's Elwood Mead and Col. William J. Barden. The report listed irrigation costs of $284 per acre under the pumping plan and $493 per acre under the gravity plan, and showed that power revenue was necessary to offset irrigation costs.

The 1932 election of Pres. Franklin D. Roosevelt brought his New Deal with an emphasis on employment and public power development. After lobbying by pumping plan advocates and U.S. senator Clarence C. Dill of Washington, in 1933 Pres. Roosevelt authorized a lower version of the dam costing $63 million as a Public Works Administration project. Designers made plans for a gravity-type dam whose foundation could support a higher dam. Before the foundations for the dam were completed, additional funds were authorized to build the dam to the intended height. The dam was designed by Bureau of Reclamation personnel under the direction of Frank Banks, with oversight by a Board of Consulting Engineers including Dr. Charles P. Berkey, Dr. W. F. Durand, D. C. Henny, Joseph Jacobs, and C. H. Paul.

Construction of Grand Coulee Dam began in 1933 and faced many challenges, starting with difficulty in getting contractors with financial capacity to bid on such a large project and including relocating American Indian graves (1,200 out of at least 3,200 were moved before the effort was stopped), diverting the river, grouting to seal cracks in bedrock, cooling very large concrete pours, providing five "twist slots" that were filled with concrete after the lake was partly filled to compensate for small distortions of the structure, providing temporary fish ladders, and building fish hatcheries near Leavenworth on Icicle River, Winthrop on the Methow River, and Ford on the Spokane River. Additional problems appeared during construction, including huge landslides, protecting newly cast concrete from freezing, ice damage to bridges, and leaking cofferdams. The contract for the low dam, which was changed to build the foundations for the high dam, was bid on June 18, 1934. This contract was awarded to a consortium known as Mason, Walsh, Atkinson, and Kier Company (MWAK), and the work was completed March 12, 1938. On December 10, 1937, the contract to finish the high dam was won by Consolidated Builders, Inc. (CBI), a consortium

including Henry J. Kaiser's Kaiser Construction Company, MWAK, Morrison Knudsen Company, Utah Construction Company, J. F. Shea Company, Inc., Pacific Bridge Company, McDonald and Kahn Company, and General Construction Company. The dam was filled on June 1, 1942, and CBI completed work on January 31, 1943.

During World War II, the dam's power was used by aluminum plants, shipyards, and a top-secret facility at Hanford, Washington, where plutonium was produced for the atomic bombs used to end the war. Irrigation was developed after the war, with dams at each end of the Grand Coulee to contain the irrigation water, and a network of canals, tunnels, siphons, and lakes to deliver the water to 550,000 to 700,000 acres in the Columbia Basin.

A third powerhouse, completed in 1980, added 4,215,000 kilowatts of much-needed generating capacity to the dam.

In 2008, Grand Coulee Dam serves America both as an important power plant and a source of irrigation water, and stands as a monument to the dream of visionaries who overcame bitter opposition, to Pres. Franklin D. Roosevelt, to the efforts and sacrifices of those who built it, and most of all, to American initiative and ingenuity.

## GLOSSARY

**ARCH:** A curved structural member that is designed to carry forces across a span. Arch dams typically span between the rock walls of a deep canyon.

**CANTILEVER:** A type of truss bridge in which the main span is supported by two piers at each end.

**CLYDE WYLIE:** A type of gantry carriage that straddles an industrial railway or roadway.

**COFFERDAM:** A temporary structure, typically made by driving sheet piling around an in-water work area, that is pumped out to dewater the work area.

**DECK:** The portion of a bridge structure that provides a roadway surface to carry traffic.

**DONKEY:** A steam-powered hoisting engine, mounted on skids with a vertical boiler and equipped to haul in one or more wire ropes, commonly used in logging. Contractors found donkeys useful when they improvised cranes, pile drivers, and other equipment.

**DRUM GATE:** A large cylindrical gate that turns on a horizontal axis and is used to regulate the flow of water into a dam's spillways.

**EARTHEN DAM:** A type of dam that is constructed using fill materials.

**FALSEWORK:** A temporary structure used to support permanent structure during construction.

**GRAVITY DAM:** A type of dam in which the mass or weight of the dam is used to resist the tendency of the dam to overturn because of hydrostatic pressure.

**GROUT:** A mixture of sand, cement, and water that can be used to repair some defects in concrete structures.

**HYDROSTATIC PRESSURE:** Pressure caused by the weight of a fluid such as water above and around a submerged structure, acting in all directions and tending to collapse submerged structures.

**KILOWATT:** A measure of electric power production. One kilowatt is equivalent to 0.746 horsepower.

**OUTLET TUBE:** A passage through a dam between the upstream side and the downstream side, controlled by gates at each end.

**PENSTOCK:** A passage that carries water from the upstream side of a dam to a turbine.

**PIER:** A vertical structure that supports the spans of a bridge, typically in water.

**PILING:** A long, slender foundation component, typically timber, that is driven into the soil.

**SHEET PILING:** Wooden planks or corrugated steel that are driven into soil and typically used to construct cofferdams and retaining walls.

**SPAN:** The distance between the supports of a structure.

**SUSPENSION:** A type of bridge in which the primary structural members are large steel cables designed to carry forces across a span.

**WHIRLEY:** A type of crane with a single boom mounted atop a turntable.

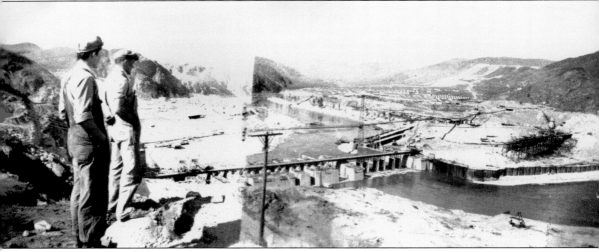

Off-duty Grand Coulee Dam workers look over their job site from a viewpoint to the southwest in this 1937 photograph. The worker at right is Ray Hobson, who worked at the dam during 1936 and 1937. Ray's first job was stripping unsound rock from bedrock on a crew equipped with sledgehammers weighing from 8 to 16 pounds, earning 25¢ per hour. Later he worked as a welder on the trestles above the block pours and finished his dam-building career as a diamond driller earning 55¢ per hour drilling holes for blasting. When not working on the dam, Ray worked at the Wallis Dairy Store making ice cream and a variety of cold treats, helped coach the Grand Coulee High School football team, and sometimes filled in on the night shift for the Grand Coulee police department. (Courtesy Ray Hobson.)

# One

# THE DREAM

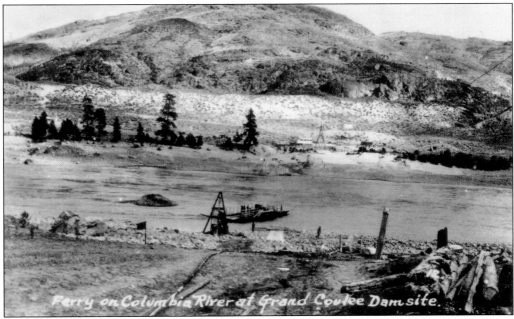

Ferry on Columbia River at Grand Coulee Dam site.

This view, looking toward the east, shows Sam Seaton's ferry crossing the Columbia River at a lonely site that was soon to become the home of Grand Coulee Dam. The calm scene belies the intense fighting between supporters of the dam and private power interests, which went on for decades before design and construction of the dam was authorized. As soon as funding was provided for the dam, this location became the site of the world's largest construction project, and later the world's largest concrete structure and power plant upon completion. The east bank of the river soon became the site of Mason City and the contractor's shops. The ferry and the road leading up from the river were soon replaced by a series of temporary and permanent bridges needed for construction of the dam and for the increased population the development brought with it. (Courtesy author.)

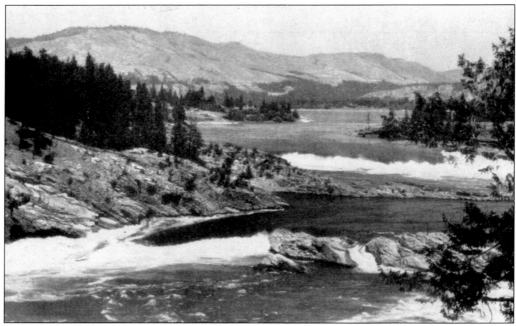

This scene shows Kettle Falls, located on the Columbia River about 100 miles above the future site of Grand Coulee Dam. Any development at Grand Coulee large enough to provide significant electrical power would inundate Kettle Falls, so Spokane's Washington Water Power Company filed for the right to build a dam at Kettle Falls in an unsuccessful attempt to block Grand Coulee Dam. (Courtesy author.)

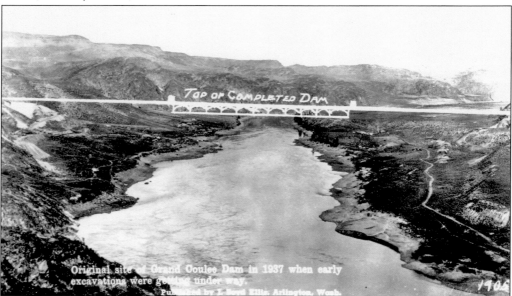

This photograph shows the future site of Grand Coulee Dam with the top of the dam marked. The markings show the "high dam" option, which was favored by supporters of Grand Coulee Dam because the increased power production would help pay for irrigation and would help develop the region. (Courtesy author.)

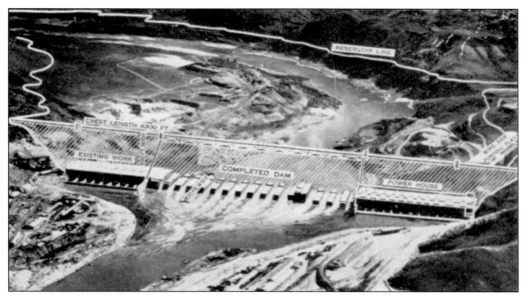

This photograph shows Grand Coulee Dam partially completed, with the top of the dam, powerhouses, and the waterline marked. This view also shows the high dam option, which by the time of this photograph had been funded. The wing dam and pumping plant shown at the right supply water to the balancing reservoir located in the Grand Coulee. (Courtesy author.)

This artist's rendition shows what the "low dam" option would have looked like. The low dam was funded at first but was designed to allow changing to the high dam when funding later became available. In the right foreground is the government's Engineer's Town, and in the left foreground is the contractor's town, known as Mason City. (Courtesy Washington State Archives.)

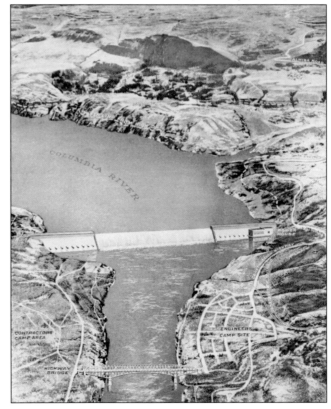

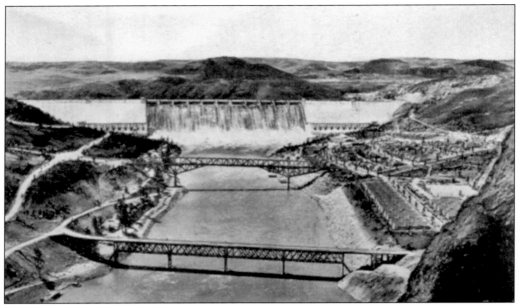

This artist's rendition shows the high dam option with the highway bridge, Engineer's Town, and Mason, Walsh, Atkinson, and Kier Company's temporary bridge in the foreground. The temporary bridge was planned to carry both railroad and vehicle traffic during construction but never carried railroad traffic. Grand Coulee Dam was designed and built as a gravity-type dam, with the weight of the dam resisting overturning forces. (Courtesy author.)

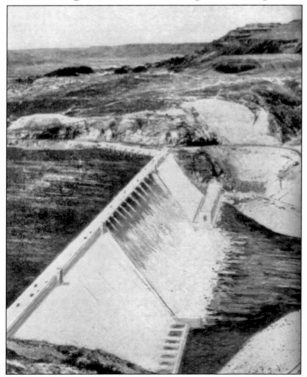

This artist's rendition also shows the high dam option, with automobile and truck traffic shown on the bridge on top of the dam to highlight its large scale. At the far end of the dam, the wing dam for the pumping station is visible, from which irrigation water was pumped into the balancing reservoir in the Grand Coulee. (Courtesy author.)

In this photograph, a Bureau of Reclamation representative points out the 18-foot-diameter penstocks on a section model of the dam and powerhouse. Also visible is a model of the complete dam with west powerhouse. Each penstock carries 141 tons of water per second to drive a loaded generator. (Courtesy author.)

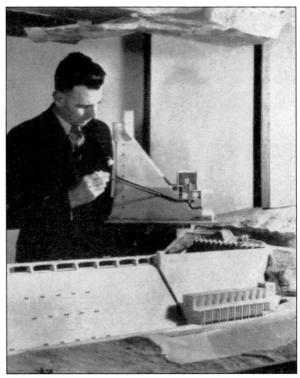

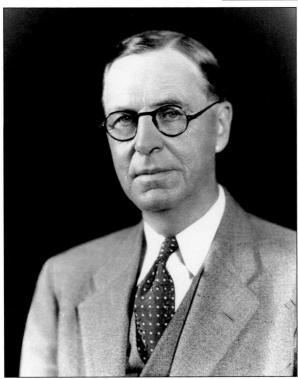

James O'Sullivan, shown in this portrait, became intrigued with a dam at Grand Coulee as an attorney in Ephrata, Washington, and supported the dam from Port Huron, Michigan, while managing his family's contracting business from 1915 to 1929. In 1929, he became executive secretary of the Columbia River Development League in Wenatchee, Washington, and in 1933, he became secretary of the Columbia Basin Commission. (Courtesy Washington State Archives.)

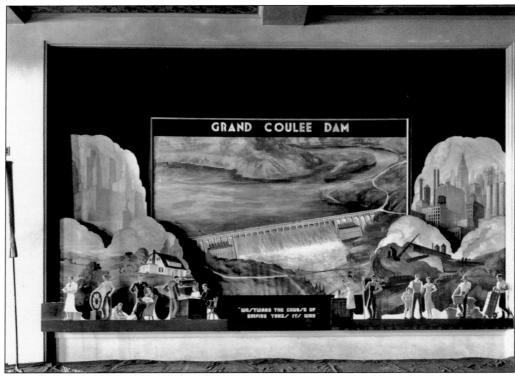

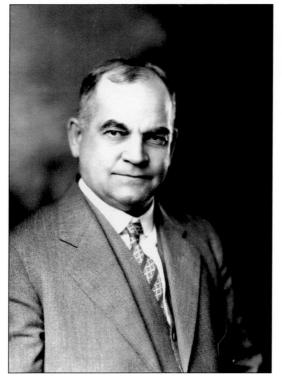

During the lean years, beginning in 1929, James O'Sullivan promoted Grand Coulee Dam by attending as many public meetings as possible, often the meetings of gravity plan supporters. He also supplied exhibits for fairs and expositions, such as this 1934 exhibit designed to show the public that Grand Coulee Dam would foster industrial, commercial, and agricultural growth in Washington. (Courtesy Washington State Archives.)

This portrait show Rufus Woods, publisher of the *Wenatchee Daily World* newspaper. Woods used his newspaper to support the idea of a dam at Grand Coulee, often rebutting information published in Spokane newspapers. Spokane was the home of Washington Water Power Company, a vehement opponent of Grand Coulee Dam. (Courtesy Washington State Archives.)

This photograph shows Pres. Franklin D. Roosevelt at the left, with Frank A. Banks of the Bureau of Reclamation at the right. The president was a strong supporter of public power, and ultimately he was responsible for funding the design and construction of Grand Coulee Dam. Banks was the government's engineer in charge of getting the dam built. (Courtesy author.)

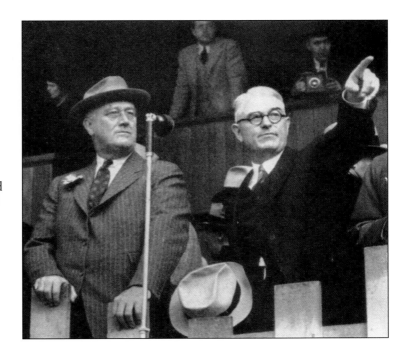

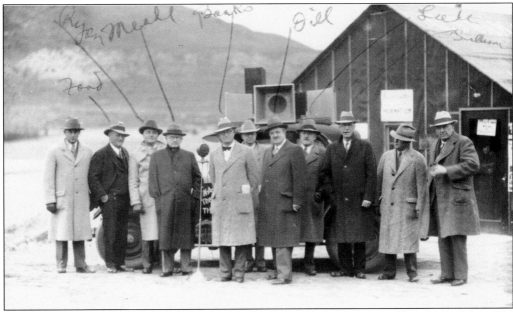

This wintry scene shows Frank A. Banks (fifth from the left), James O'Sullivan (third from the right), and U.S. senator Clarence Dill (fifth from the right). Senator Dill pressured his friend President Roosevelt to build Grand Coulee Dam. "Ryan" probably refers to a representative of the David H. Ryan Company of San Francisco, the excavation contractor and builder of a 32-mile branch railroad line to the dam. (Courtesy Washington State Archives.)

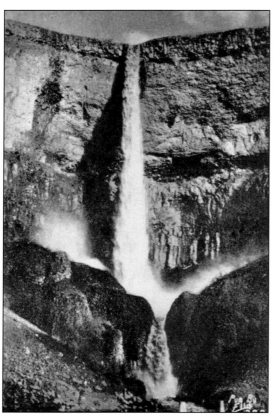

This photograph shows the Devil's Punchbowl, a spectacular waterfall, pool, and secondary waterfall in the rim of the Grand Coulee. This view is a good illustration of the enormous scale of the Grand Coulee, with many of the coulee walls consisting of sheer bluffs and cliffs nearly 1,000 feet high. (Courtesy author.)

This scene shows Steamboat Rock, 2 miles wide, half a mile long, and 900 feet high. During Ice Age floods, the Grand Coulee carried the Columbia River, and Steamboat Rock was an island 2 miles wide, between 800-foot-high waterfalls each 2 miles wide. Steamboat Rock became an island again when the balancing reservoir was filled. (Courtesy author.)

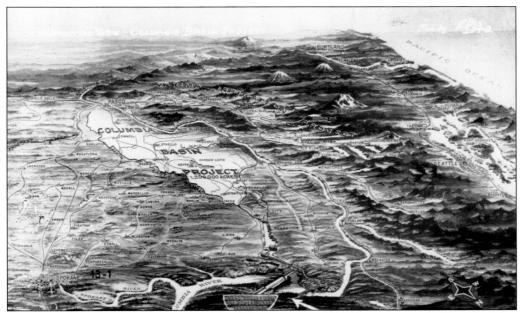

This aerial scene looking toward the southwest shows the Columbia Basin Project as a 1.2-million acre irrigation development with the balancing reservoir and the storage reservoir behind Grand Coulee Dam. The location of the proposed irrigated lands is shown in relation to Spokane, Seattle, and Tacoma, Washington, and Portland, Oregon. Actual development of irrigation reached 550,000 to 700,000 acres. (Courtesy author.)

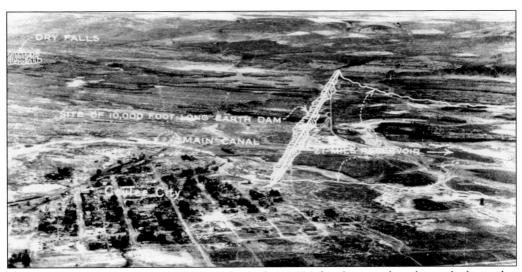

This aerial scene looking toward the west shows the 10,000-foot-long earthen dam to be located at Coulee City that would contain the 27-mile-long balancing reservoir. Also shown to the southwest is Dry Falls, a 400-foot-high Ice Age waterfall. Canals were planned to carry the irrigation water from Coulee City to the Columbia Basin Project. (Courtesy author.)

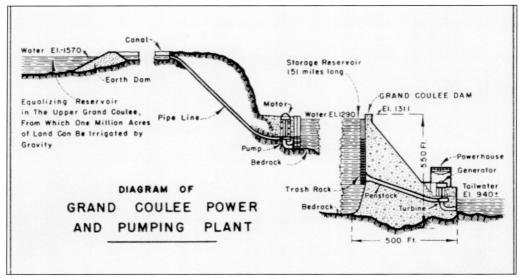

This schematic diagram illustrates the hydraulics of Grand Coulee Dam. The dam impounds water to an elevation of 1,290 feet above sea level. Some of this water goes through the spillways of the dam, some of the water goes through the penstocks to drive the turbines to generate electric power, and some of the water is pumped to the balancing reservoir to be used for gravity-flow irrigation. (Courtesy author.)

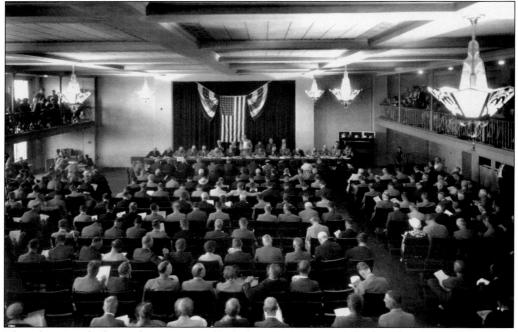

This photograph shows the opening of bids for construction of the low-dam version of Grand Coulee Dam in the auditorium of Spokane's Civic Building on June 18, 1934. The low bidder was Mason, Walsh, Atkinson, and Kier Company (MWAK) at $29,339,301.50. MWAK was a consortium consisting of Silas Mason Company of New York, Atkinson-Kier Company of San Francisco, and Walsh Construction Company of Davenport, Iowa. (Courtesy Washington State Archives.)

# Two

# CONSTRUCTION TOWNS AND INFRASTRUCTURE

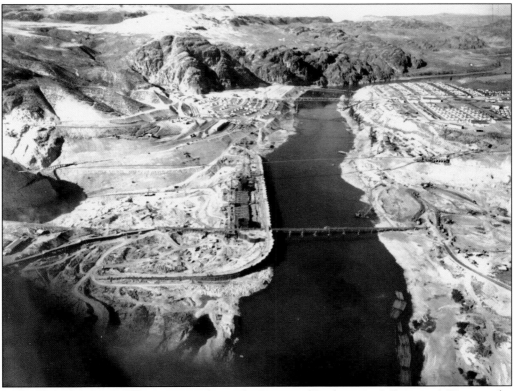

This aerial view looking downstream shows the Bureau of Reclamation's Engineer's Town at the foot of the hill on the left side of the Columbia River and MWAK's town Mason City directly across the river. In the foreground is the west-side cofferdam, 2,000 feet long, 50 feet thick, and 110 feet above bedrock. Starting upstream at the cofferdam, the first bridge is a trestle carrying the conveyor from the east-side excavation to be deposited in Rattlesnake Canyon at the head of Grand Coulee. The second bridge is a suspension bridge carrying a conveyor for sand and gravel from the east side to the west-side concrete mixing plant (Westmix plant). The deck of the suspension bridge is 150 feet above water level. The third bridge is the government's cantilever-type highway bridge. The fourth bridge is MWAK's temporary construction bridge. (Courtesy Washington State Archives.)

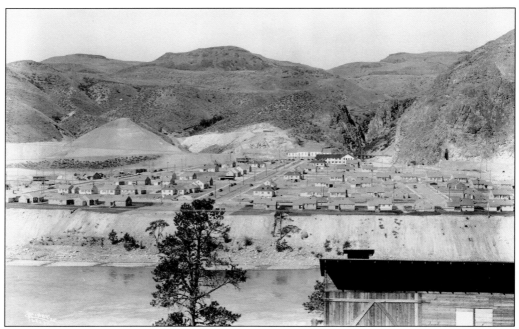

This 1935 photograph shows Engineer's Town as viewed from a high point on the east side across the Columbia River. Electric power poles are visible throughout the town, which was considered to have the best housing in the area. The Bureau of Reclamation's administration building can be seen at the foot of the hill. (Courtesy Washington State Archives.)

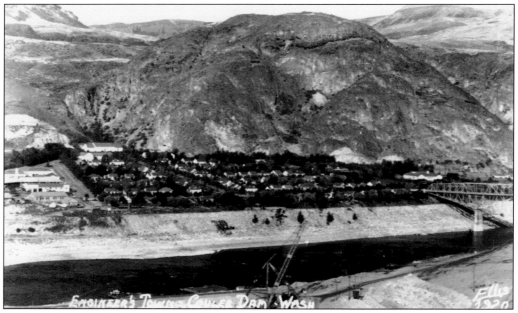

This later photograph shows Engineer's Town, which was later combined with Mason City and called Coulee Dam, with trees that were not visible in the 1935 view. Engineer's Town was owned by the government until Congress allowed the Bureau of Reclamation to sell the houses in 1956. Coulee Dam voted to incorporate as an independent city on February 16, 1959. (Courtesy author.)

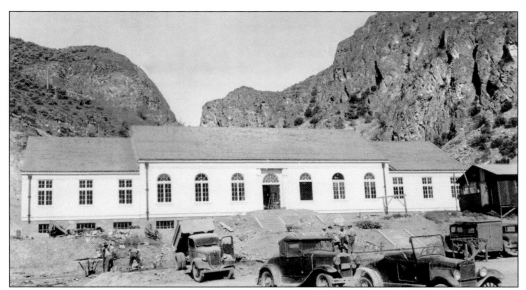

This undated photograph shows the Bureau of Reclamation's administration building in Engineer's Town. Shown from left to right are a 1935 Ford truck with a dump bed, a 1930 or 1931 Ford Model A roadster, and a 1926 or 1927 Ford Model T roadster missing its top. (Courtesy Washington State Archives.)

This undated photograph shows the Bureau of Reclamation basketball team in the school gymnasium at Engineer's Town. The nearby town of Grand Coulee also had high school sports teams that played six or seven small towns within about 80 miles, and dam worker Ray Hobson helped coach the football team there, teaching team members how to block, kick, and crab block. (Courtesy Washington State Archives.)

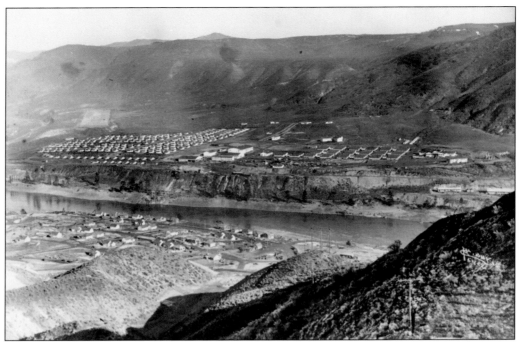

This photograph shows Mason City on the far side of the river, with Engineer's Town in the foreground. Built by MWAK in 1934 to provide a place for its workers to live, Mason City was sold to the Bureau of Reclamation in 1937, just before the completion of MWAK's contract. (Courtesy Washington State Archives.)

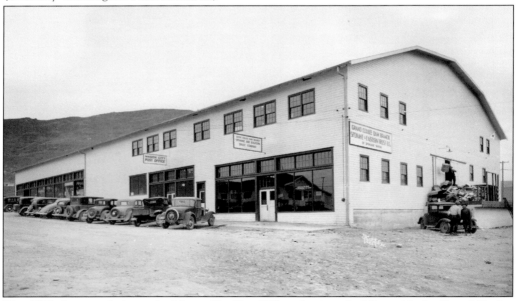

This 1935 photograph shows the Mason City Post Office, sharing a building with the Grand Coulee Dam branch of Spokane and Eastern Trust Company of Spokane and an unnamed business. A 1929 Chevrolet coupe is parked at the loading dock and a 1930 or 1931 Ford Model A roadster is at right in front of the post office. (Courtesy Washington State Archives.)

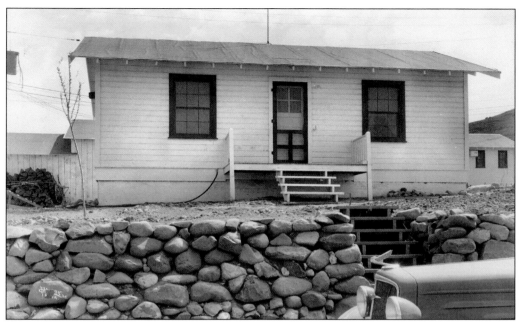

This photograph dated 1935 shows a typical small house in Mason City. Three-bedroom homes rented for $32 per month. With a population of 3,000 citizens, all of Mason City was provided with electric power for three mils per kilowatt-hour. The typical electric bill for a house with electric heating was $6.50 per month in winter and $1.50 per month in summer. (Courtesy Washington State Archives.)

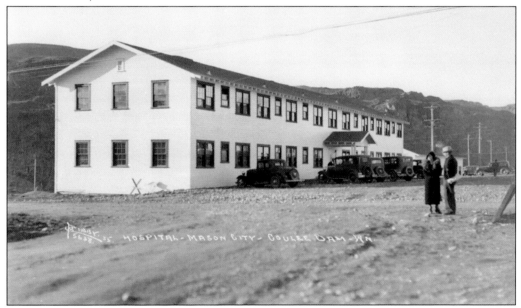

This 1935 photograph shows the 60-bed Mason City hospital. Several years later, when Consolidated Builders Incorporated (CBI), a consortium led by Kaiser Construction Company of Seattle, Washington, was completing the dam, Henry J. Kaiser started the Kaiser Permanente Medical Care Program to guarantee medical care for CBI employees. (Courtesy Washington State Archives.)

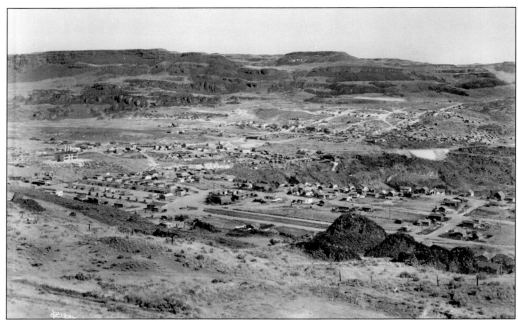

This scene, dated 1935, shows some of the private towns that sprang up around Grand Coulee to provide homes for workers near the dam site. Accommodations were significantly poorer than in Mason City or Engineer's Town, and this area was known as "Shack Town." Electric power was not as common here as in Mason City. (Courtesy Washington State Archives.)

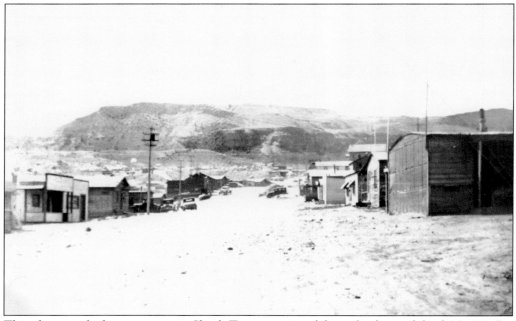

This photograph shows a street in Shack Town, as viewed from the front of shack No. 23. For shack No. 23, the rent was $40 per month, which was shared by Ray Hobson and three other workmen. Shack Town had few amenities with electric power for a light bulb and a hot plate available in each shack and a shower house on each street. (Courtesy Ray Hobson.)

This photograph shows the view looking from the back of shack No. 23. The contrast between this view and the photograph at the bottom of page 26 is dramatic. This canyon is an excellent example of the geology of the Columbia Basin region and the Grand Coulee in particular. (Courtesy Ray Hobson.)

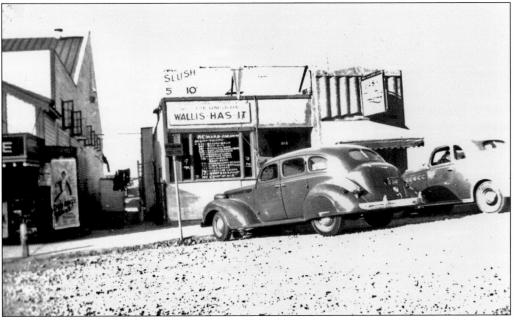

One of the businesses in Shack Town was the Wallis Dairy Store, shown with an impressive menu of treats listed on the window. Dam worker Ray Hobson also worked at the creamery and could make all of the listed treats. The automobile in front is the store owner's 1936 Dodge Series D2 four-door sedan used by the owner's son to deliver milk. (Courtesy Ray Hobson.)

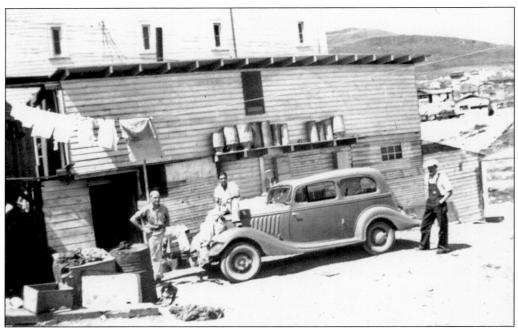

This photograph shows the sales force behind the Wallis Dairy Store. Ray Hobson is standing at the left and Aubrey McShane at the right. The automobile is a 1934 Terraplane two-door sedan. A row of battered, empty milk cans waits on a shelf, while aprons and towels dry on a clothesline. (Courtesy Ray Hobson.)

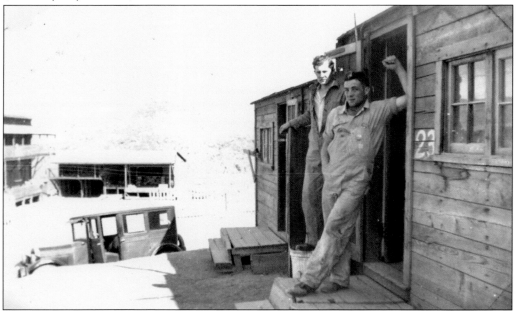

Ray Hobson (right) and Aubrey McShane are shown in front of shack No. 23 in this *c*. 1937 photograph. Aubrey handled wet concrete in block pours as the dam was built. Ray's 1926 Chevrolet four-door sedan is parked in the background. This photograph attests to the temporary nature of the housing and other buildings in Shack Town. (Courtesy Ray Hobson.)

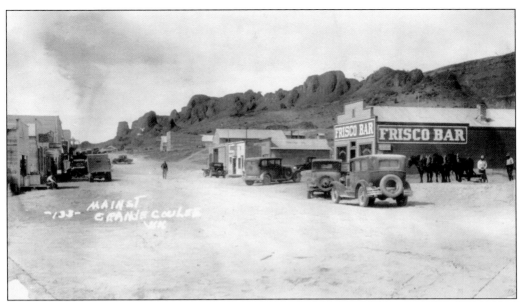

The town of Grand Coulee's Main Street is shown in this undated photograph. The town of Grand Coulee is located west of Grand Coulee Dam above the old river channel known as the Grand Coulee. On the street are assorted automobiles, a truck, numerous citizens, and a four-horse team with a scraper. The only identifiable business is the Frisco Bar, which claimed the "longest bar in town." (Courtesy Washington State Archives.)

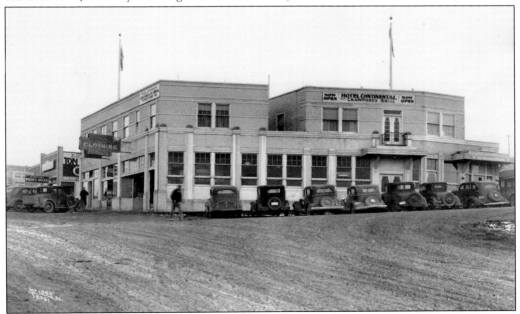

This photograph, dated 1936, shows several businesses located in Grand Coulee. Pictured from left to right are the Grand Coulee Post Office, Bjorklund's Men's Wear, Ross Clothing and Shoes, and Hotel Continental, which also housed Crawford's Grill. A sign above Ross's indicates that the Hotel Continental is furnished by the Grunbaum Brothers Furniture Company of Seattle. (Courtesy Washington State Archives.)

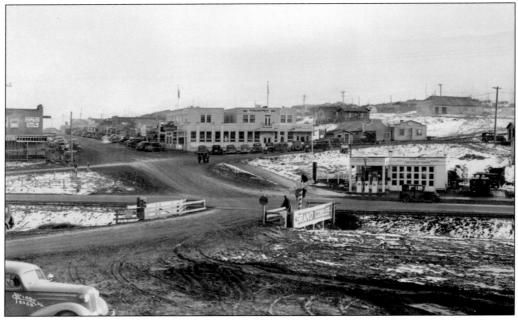

This 1936 photograph shows another view of Grand Coulee. Pictured from left to right are Center Drug, a beauty shop, a Texaco station, a Union 76 station, and a law office. The truck just above the Union 76 station is from the Piano Exchange in Spokane. (Courtesy Washington State Archives.)

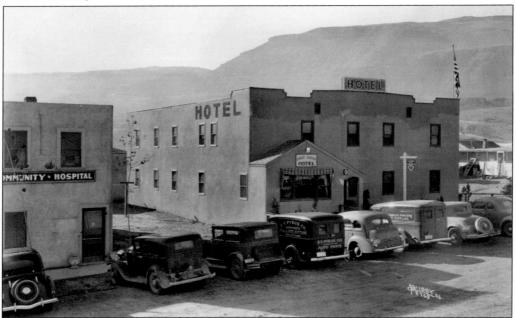

This 1936 photograph also shows Grand Coulee. The Coulee Center Hotel displays its American Automobile Association (AAA) sign for travelers at the right, and the Coulee Center Community Hospital is at the left. E. T. Phybus Company, an auto parts store, must be located nearby as evidenced by the panel wagons parked on the street. (Courtesy Washington State Archives.)

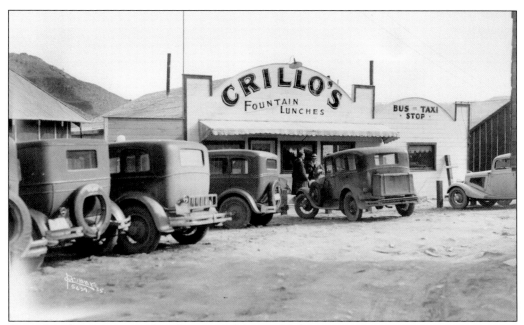

One of the businesses to take advantage of the world's largest concrete construction project was Grillo's, which offered lunches, a soda fountain, and a bus and taxi stop, shown in this 1935 photograph. Directly in front of Grillo's is a 1930 or 1931 Ford Model A four-door sedan. (Courtesy Washington State Archives.)

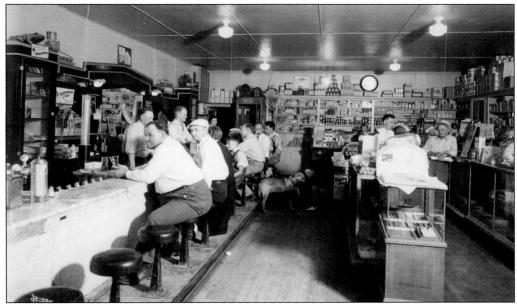

Another business capitalizing on the world's largest concrete construction project was this combination bar and store, photographed in 1935. A wide variety of products was offered, including Olympia Beer; Bohemian Club Draught beer; Wright wines; Van Dyck, Mozart, and William Penn cigars; Union House and Sir Walter Raliegh tobacco; Palmolive Soap; Rite-Rite pencils; and dollar pocket watches. (Courtesy Washington State Archives.)

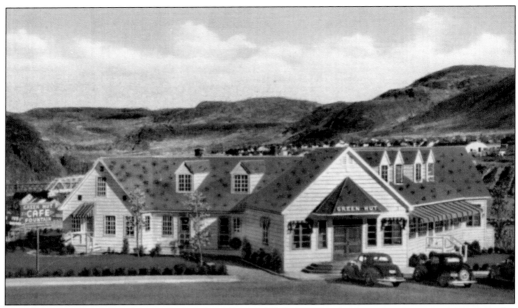

A well-known business that capitalized on the world's largest concrete construction project was the Green Hut Café, located just below Grand Coulee overlooking the dam. Offering fountain treats, curios, and novelties, the Green Hut Café was a local landmark well beyond the construction boom until it burned on September 11, 1964. (Courtesy author.)

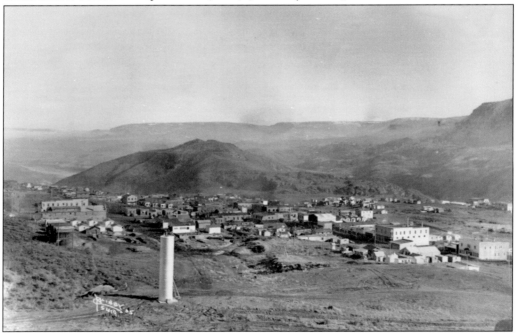

This 1935 photograph shows Grand Coulee, Washington, from a nearby hill. Grand Coulee had none of the restrictions of the government and company towns closer to the dam but also received none of the subsidies. Some citizens of Grand Coulee wanted the government to remove the town of Coulee Dam after construction of the dam. (Courtesy Washington State Archives.)

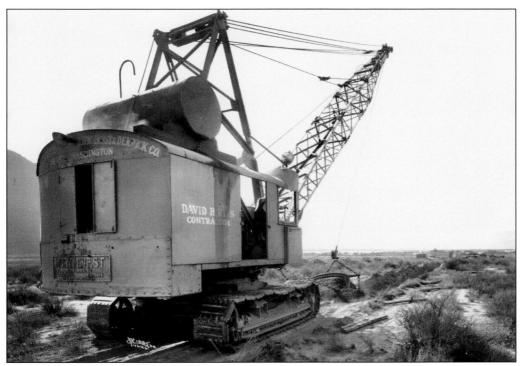

This 1934 photograph shows a Northwest dragline belonging to David H. Ryan working on the 32-mile railroad connection to Grand Coulee Dam. The Great Northern and Northern Pacific railroads agreed to build the connection but only if the government promised to ship just by rail, and trucking companies protested. The government put the job out for bids, and Ryan won the contract. (Courtesy Washington State Archives.)

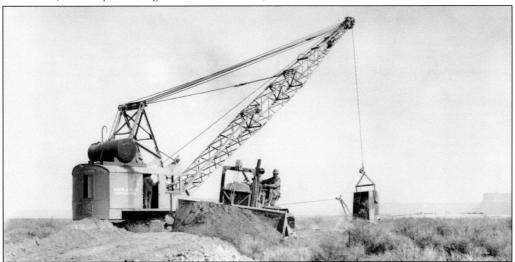

This 1934 scene shows David H. Ryan's Northwest dragline hauling back its empty bucket while a Caterpillar 60 tractor with a bulldozer moves excavated material. The dragline outfit was purchased from Pacific Hoist and Derrick Company of Seattle. Caterpillar built the 60 tractor until 1931, when it was replaced by a diesel model. (Courtesy Washington State Archives.)

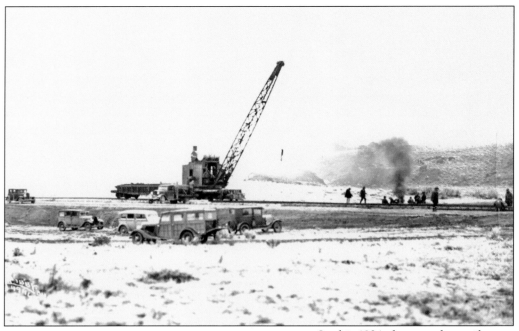

In this 1934 photograph, a rail-mounted crane on the 32-mile railroad is being filled with water or fuel from a tank on a flatbed truck. The 1926 or 1927 Ford Model T Tudor sedan to the right of the wooden station wagon has a blanket over the hood in an attempt to keep the engine warm on what appears to be a very cold day. (Courtesy Washington State Archives.)

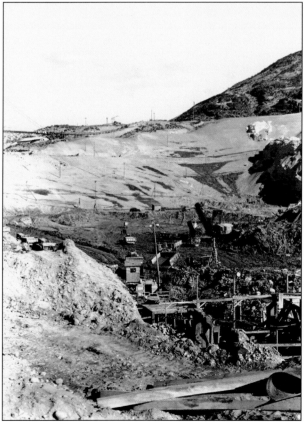

The construction of Grand Coulee Dam depended on a vast network of conveyor belts, both to remove excavated materials and to deliver aggregate. This photograph shows a large electric shovel loading 12-to-20-cubic-yard side-dump trailers pulled by Caterpillar tractors, which are hauling to the conveyor. The conveyor system carried the material to Rattlesnake Canyon. (Courtesy Washington State Archives.)

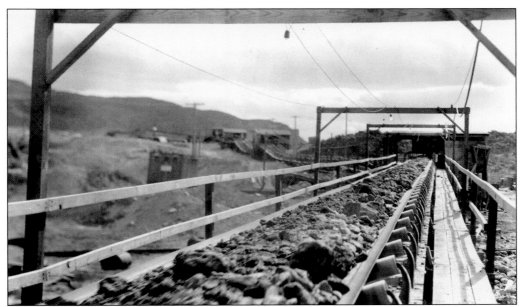

This photograph shows a section of the $950,000 conveyor system, at least 6,600 feet long, that carried excavated material from the dam site to Rattlesnake Canyon. The 5-foot-wide conveyor belt system made by Jeffrey Manufacturing Company handled 50,000 cubic yards of material per day, lifting the material 500 feet. A catwalk was provided for maintenance of the conveyor. (Courtesy Washington State Archives.)

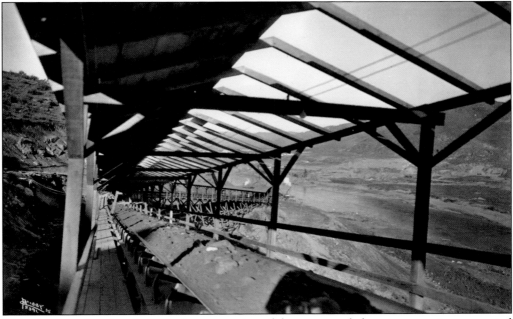

This photograph, taken in 1935, shows a section of the conveyor belt system carrying excavated material up a steep grade toward Rattlesnake Canyon. This section of the conveyor has a partially completed roof, presumably intended to keep rain and weather from making the materials harder to handle. (Courtesy Washington State Archives.)

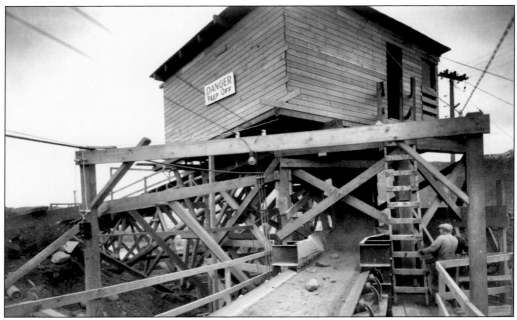

This 1935 scene shows one of the many houses that covered electric motor drives and transitions from one section of conveyor to another. Most of the material handled by the conveyor was soil and clay. A light bulb hanging above the conveyor attests to the fact that the conveyor operated day and night. (Courtesy Washington State Archives.)

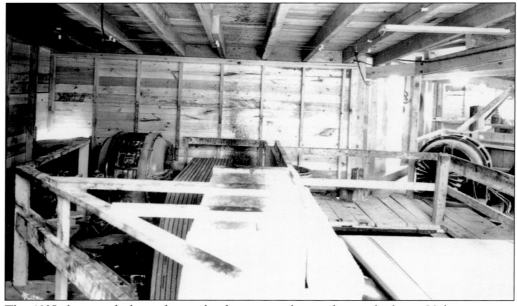

This 1935 photograph shows the inside of a conveyor house, this one built in a V shape to serve two sections of conveyor belt. The house protected the large electric motors and heavy-duty vee-belt drives that powered the conveyors. The vee-belt drive shown has a grand total of 14 belts, and the conveyor system was powered by electric motors having 5,000 horsepower total capacity. (Courtesy Washington State Archives.)

The conveyor systems included at least one section of tunnel, shown under construction in this undated photograph. The tunnel was located where the aggregate conveyor approached MWAK's screening plant on the east side of the river. Apparently a tunnel was more economical or faster to build than the conveyors that would be required to move the aggregate past this point. (Courtesy Washington State Archives.)

This 1935 scene shows the discharge end of the conveyor system at the far left dumping excavated materials into Rattlesnake Canyon. Prefabricated sections of conveyor are supported on steel rails, and the section at the left appears to swing by rolling on rails. At the left, carpenters are building supports for another conveyor belt. (Courtesy Washington State Archives.)

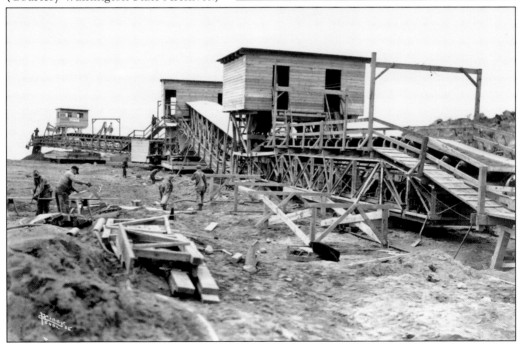

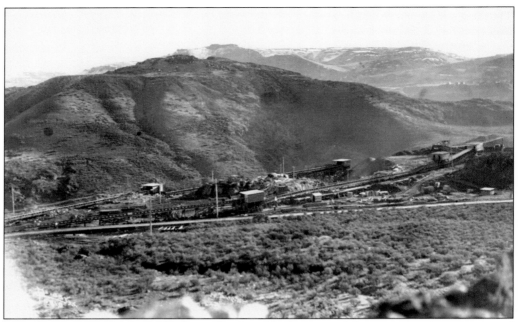

This photograph, taken in 1935, shows Rattlesnake Canyon and the network of conveyors used to dump the excavated material into the canyon. This operation handled approximately 10 million cubic yards of excavated soil and clay in 13 months, and at top speed, it dumped 1.3 tons of material each second. (Courtesy Washington State Archives.)

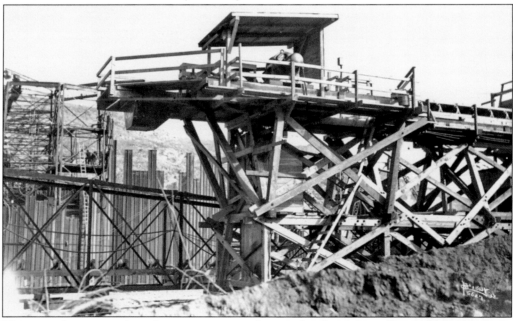

This view shows a section of conveyor mounted on steel rails, supported by timber cribbing. In the background, a section of steel boom conveyor waits to be set up, and a steel tower of similar design to MWAK's concrete mixing plants is being built behind steel sheet piles. (Courtesy Washington State Archives.)

This October 31, 1935, photograph shows the No. 1 conveyor and the end of a boom conveyor. The conveyor system that removed excavated material worked very well, and a similar system was set up to carry aggregate from the source, to the screening plant, and onward to the concrete mixing plants. (Courtesy Washington State Archives.)

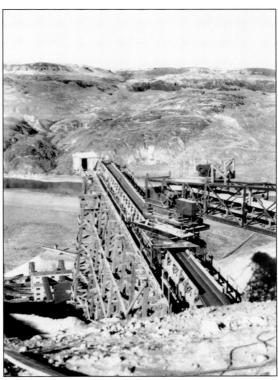

This photograph, dated February 15, 1936, shows MWAK's temporary bridge for the conveyor carrying excavated material from the east side of the river to Rattlesnake Canyon. February 1936 was so cold that most work was suspended, and the bridge was eventually wrecked by ice. In the background is the suspension bridge carrying the aggregate conveyor. (Courtesy Washington State Archives.)

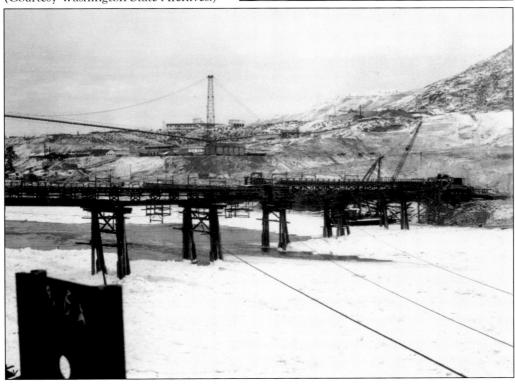

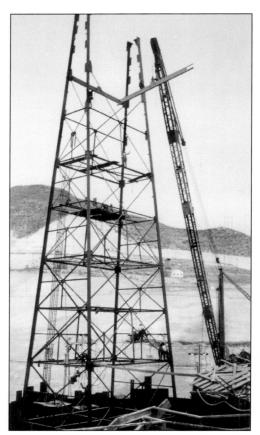

This photograph shows workmen and a crane erecting the west main tower for the suspension bridge to carry the aggregate conveyor. A plank provides access to the bottom of the tower, and a workman clings to the tower leg, waiting to guide the newest piece into place. (Courtesy Washington State Archives.)

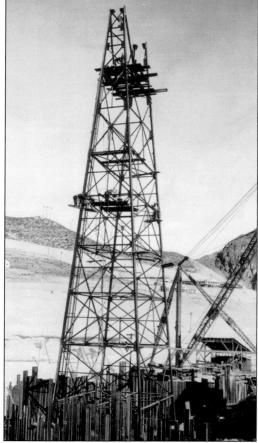

This view shows the 325-foot west main tower of the suspension bridge for the aggregate conveyor with more members in place. Workmen have extended the ladder, complete with a safety cage, at the left side of the tower nearly up to the highest planked level. The steel sheet pilings are part of the west-side cofferdam. (Courtesy Washington State Archives.)

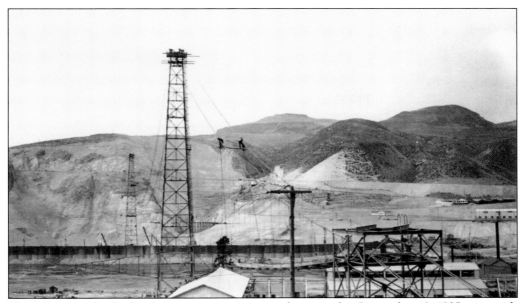

The suspension bridge for the aggregate conveyor is shown in this September 12, 1935, view with towers nearly completed and main cables strung from the towers across the river. The workmen on the plank, partway up the cables toward the first tower, are rigging vertical suspender cables to support the conveyor deck from the main cables. (Courtesy Washington State Archives.)

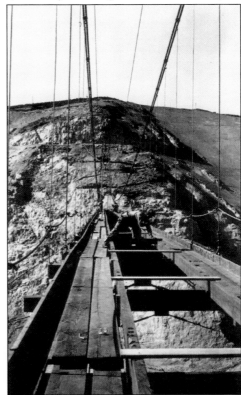

This photograph, dated September 25, 1935, shows a workman on the planked catwalk of the suspension bridge working on the timber supports for the conveyor system. Ropes were provided as handrails for the catwalks. In the background is the rock cliff at the west end of the dam, where the Westmix plant would be located. (Courtesy Washington State Archives.)

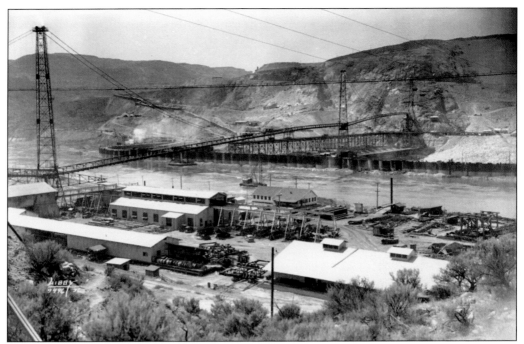

This 1936 photograph shows the completed suspension bridge for the aggregate conveyor, looking from the east side of the river toward the west end of the dam. This bridge had two main spans of 1,437 feet each. The steel trusses extending out laterally from the main towers at deck level supported cables that stabilized the deck, necessary in this high-wind area. (Courtesy Washington State Archives.)

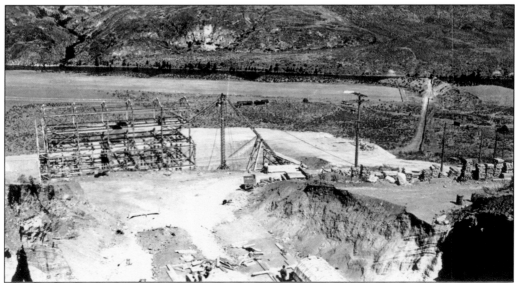

This photograph, taken on June 25, 1935, shows MWAK's screening plant under construction. The steel building, with at least four stories visible, is being erected with the help of the crane set up to the right. At the lower right, the end of the aggregate conveyor tunnel can be seen under construction. (Courtesy Washington State Archives.)

This view from July 11, 1935, shows the third floor of the screening plant under construction. The screening plant separated gravel into four sizes of 3/16 to 3/4 of an inch, 3/4 to 1½ inches, 1½ to 3 inches, and 3 to 6 inches, and sand into three sizes ranging from 100-mesh to 3/16 of an inch. (Courtesy Washington State Archives.)

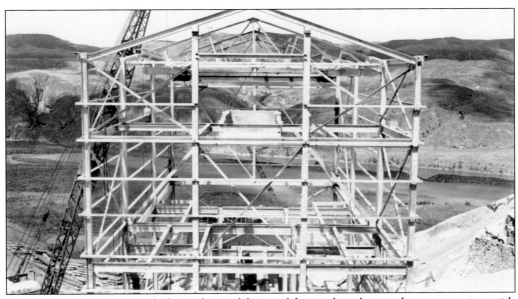

This July 3, 1935, photograph shows the steel frame of the crusher plant under construction, with MWAK's crane at the lower left. An electric-powered bridge crane has already been installed above the top story, and a heavy machine base is partly constructed on the top floor. (Courtesy Washington State Archives.)

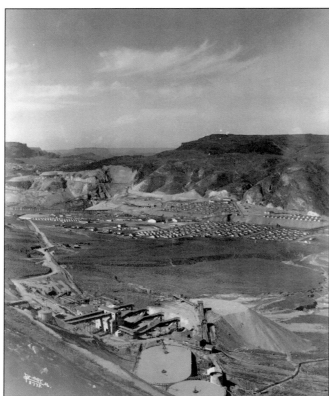

This 1936 view shows MWAK's aggregate plant located 1.5 miles from the dam. Conveyors fed rock into the crusher building, and a series of trammel screens separated the aggregate into four grades of gravel and three grades of sand. The clarifier tanks shown in the foreground treated wash water for reuse. A large pile of discarded tailings is visible to the right. (Courtesy Washington State Archives.)

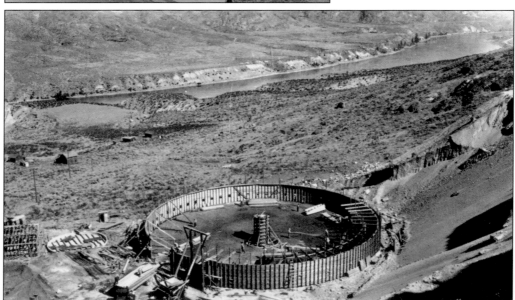

This photograph, dated August 9, 1935, shows one of the clarifier tanks under construction. The clarifier tanks were used to reclaim used aggregate wash water so that it was clean enough to reuse, saving the cost of pumping clean water up 650 feet from the river. (Courtesy Washington State Archives.)

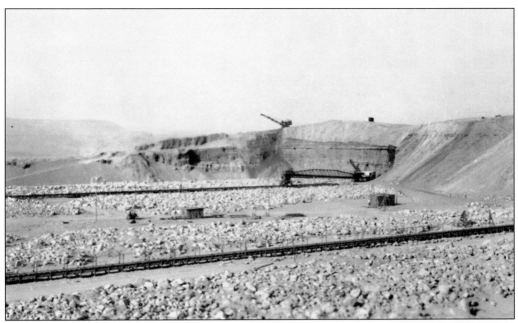

This October 19, 1935, photograph shows the Brett gravel pit 2 miles east of the dam, the government-provided source of 25,000 cubic yards of aggregate each day. The shovel feeds rock into a boom conveyor that carries the rock to a fixed conveyor, from which the rock is carried by the conveyor system to the screening plant. Another shovel works on the hill behind. (Courtesy Washington State Archives.)

This scene, on October 10, 1935, shows the supports for the west-side concrete mixing plant (Westmix plant) under construction. Work progressed both day and night, with lighting attached to the nearly complete aggregate conveyor suspension bridge. The mixing plant supports appear benched into the rock cliff wall. (Courtesy Washington State Archives.)

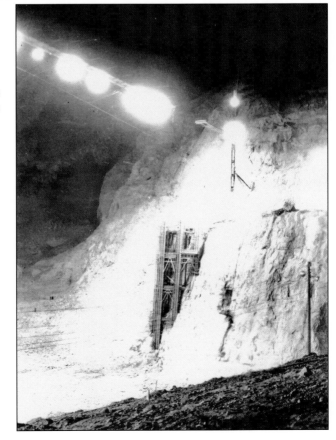

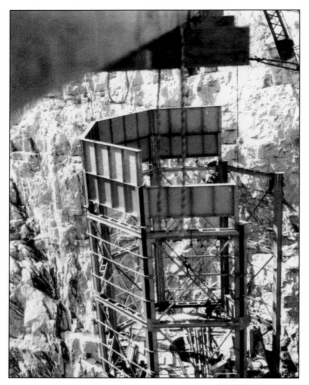

By October 19, 1935, the steel structure of the Westmix plant had nearly reached full height, as shown by this view from the bottom of the aggregate conveyor suspension bridge. The steel girders around the top of the structure will form bins for cement and various sizes of aggregate. (Courtesy Washington State Archives.)

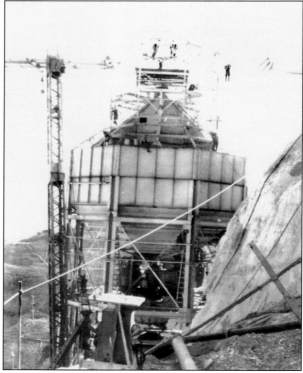

On October 31, 1935, workers were constructing the building atop the Westmix plant. The building housed the end of the conveyor and covered the aggregate bins. The kegs near the workers probably held fasteners. A derrick is seen to the left of the plant. (Courtesy Washington State Archives.)

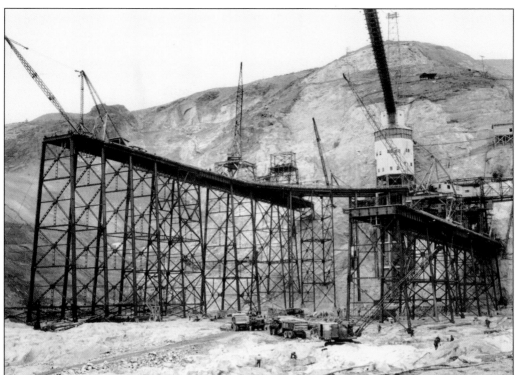

The completed Westmix plant is shown in this undated photograph. The plant could produce up to 6,000 cubic yards of concrete per day, and railroad tracks on top of the trestles provided a means to deliver the concrete to the dam. Overhead, the end of the aggregate conveyor suspension bridge can be seen. (Courtesy Washington State Archives.)

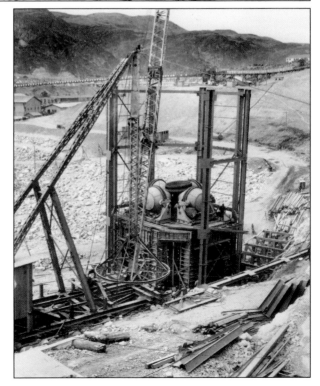

The east-side concrete mixing plant (Eastmix plant) is under construction in this March 16, 1936, photograph. The plant's four 75-horsepower Koehring concrete mixers have already been set in place at their level within the structure. Smoke or steam from the contractor-built derrick outfit can be seen at the lower left. (Courtesy Washington State Archives.)

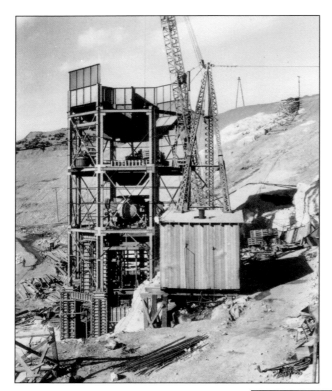

This March 18, 1936, photograph shows the Eastmix plant structure with the cement and aggregate bins under construction. On the level above the concrete mixers, some of the weighing and mixing equipment has been set in place, and the bottom of the bin is visible. (Courtesy Washington State Archives.)

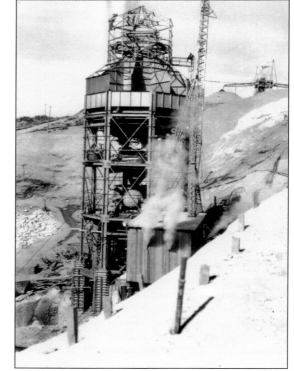

This April 2, 1936, scene shows the Eastmix plant with workers constructing the building that enclosed the end of the conveyor on top. The partitions between the bins can clearly be seen. There were two bins for cement, one for sand, and one for each of four sizes of gravel used. (Courtesy Washington State Archives.)

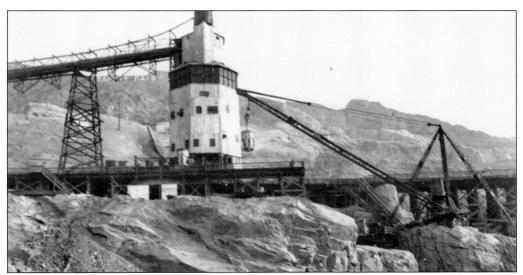

This view shows the completed Eastmix plant. The plant was over 100 feet tall and 45 feet wide. At the left is the conveyor delivering aggregate, and to the right is the trestle leading to the dam. The crane in the right foreground transfers large buckets of wet concrete from the mixing plant to the trestle. (Courtesy Washington State Archives.)

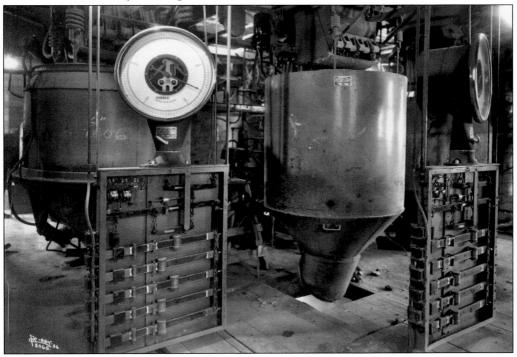

This 1936 photograph shows the weighing and mixing equipment in one of the concrete mixing plants. The elaborate scales are Johnson weigh batchers, and the funnel-shaped hoppers are Johnson measuring hoppers, made by the C. S. Johnson Company of Champaign, Illinois. Electrically operated, push-button controls allowed one operator to control the quantities of water, cement, sand, and gravel in each batch. (Courtesy Washington State Archives.)

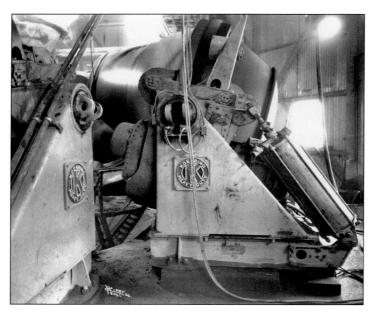

This 1936 photograph shows the Koehring heavy-duty concrete mixers in one of the concrete mixing plants. Each plant had four of these mixers, each capable of mixing 4 cubic yards of concrete. The large, compressed-air actuator at the right was used to dump the mixer. Through efficiency tests, MWAK made changes in mixer blades and controls, reducing batch times from 3.5 minutes to 2 minutes. (Courtesy Washington State Archives.)

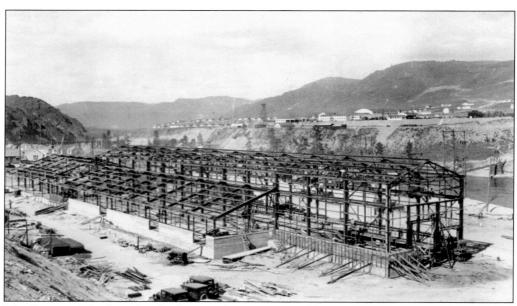

The Bureau of Reclamation built a warehouse, seen under construction in this May 24, 1935, photograph. The warehouse has a concrete stem wall foundation and a steel frame. Engineer's Town and the partially complete MWAK temporary bridge are in the left background, and Mason City is visible across the Columbia River. (Courtesy Washington State Archives.)

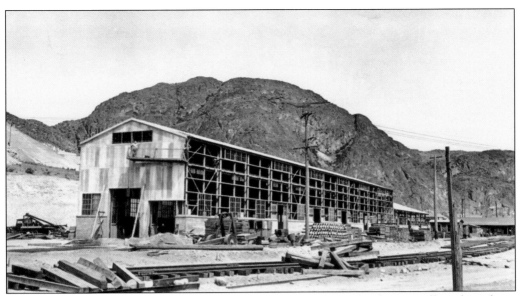

By June 23, 1935, the Bureau of Reclamation's warehouse had a roof and some walls and windows, as shown in this photograph. Two workers work from a sloping, hanging platform in the warehouse's gable end, and the railroad tracks that serve the warehouse are visible in the foreground. (Courtesy Washington State Archives.)

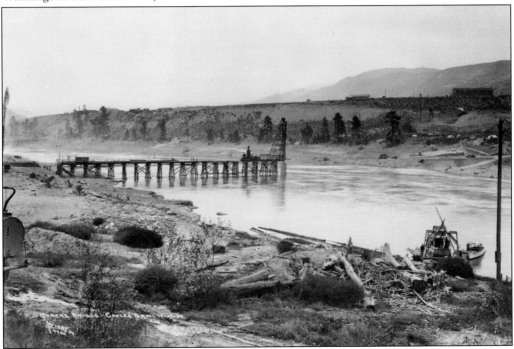

This 1934 scene shows pile driving for MWAK's first bridge at the dam site. MWAK employees floated logs down the Columbia River from Kettle Falls and drove piles using the steam donkey–powered pile driver, shown, over a three-week period. The bridge was opened to traffic late in October, and it was destroyed by an ice jam in January 1935. (Courtesy Washington State Archives.)

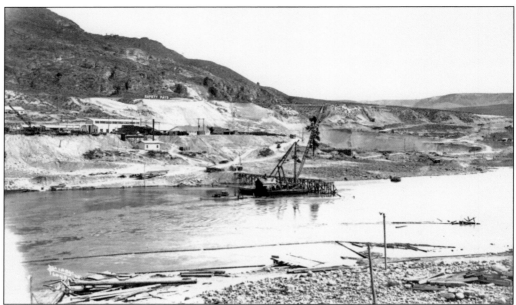

This 1935 photograph shows a barge-mounted steam pile driver building another temporary bridge near MWAK's shops upstream from the timber pile bridge that was destroyed by ice in January 1935 and downstream from the conveyor carrying excavated material across the river into the west cofferdam. A 30-foot sign with 6-foot-high letters on the hillside declares "Safety Pays." (Courtesy Washington State Archives.)

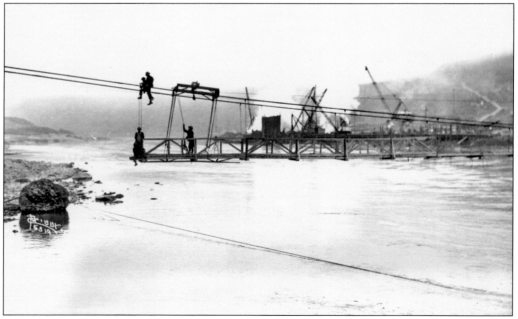

This 1935 photograph shows MWAK workers attaching suspender cables and deck to the main cables of the second suspension-type foot bridge. MWAK built the first suspension-type foot bridge after the loss of their trestle bridge in January 1935, but promptly removed it in February 1935 because it was in the way. (Courtesy Washington State Archives.)

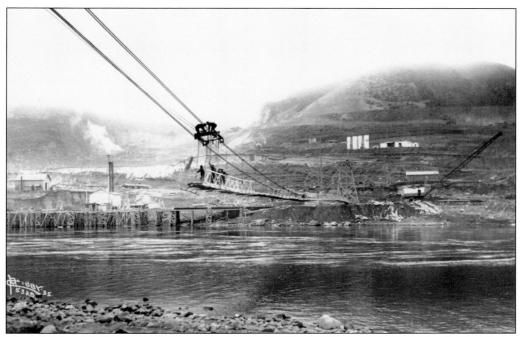

This photograph, dated 1935, shows another view of MWAK's second suspension bridge under construction. This bridge was built from the east side of the river, and the bridge's deck and most of its stiffening trusses are complete from the east side. The function of the stiffening trusses is to support the deck between the suspender cables. (Courtesy Washington State Archives.)

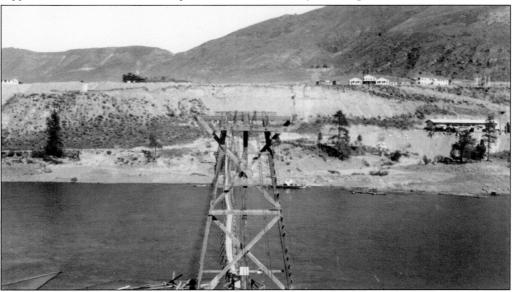

On April 21, 1935, during strong winds, a photographer recorded this view of the newly opened second suspension bridge with its deck deflecting toward the downwind direction. The main cables appear to be simply draped over a rounded piece of timber at the top of the timber tower, which has rungs nailed to it to provide a ladder for maintenance access. (Courtesy Washington State Archives.)

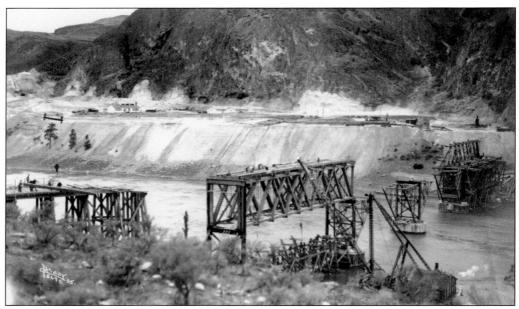

This 1935 photograph shows MWAK's timber temporary bridge under construction. An overhead cable strung across the Columbia River allowed some of the timbers to be delivered by a high-lead system controlled by steam donkeys, such as the one near the opposite end of the bridge. A barge-mounted crane at the lower right appears to be removing falsework. (Courtesy Washington State Archives.)

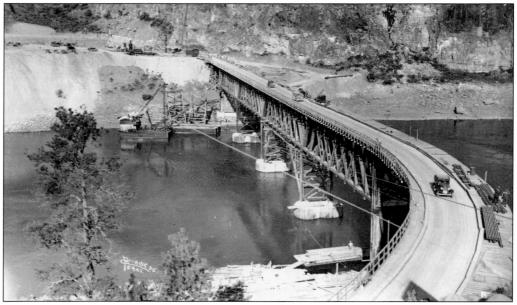

MWAK's temporary bridge is complete enough to carry vehicles and pedestrians in this 1935 photograph. To the right, a temporary platform supporting materials and equipment is visible. This bridge was intended to carry rail traffic, but the railroad could not reach the bridge because of landslides on the river bank. A 1932 Ford sedan leads other vehicles across the bridge. (Courtesy Washington State Archives.)

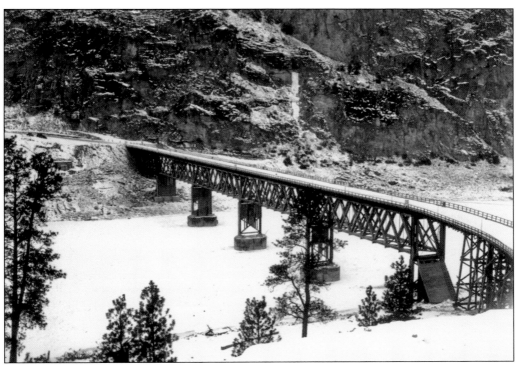

MWAK's temporary bridge is complete as shown in this snowy photograph dated February 16, 1936. The Columbia River appears to be completely frozen over, and records show that most work stopped because of extreme cold weather in February 1936. This bridge was located just downstream from the government's cantilever-type highway bridge. (Courtesy Washington State Archives.)

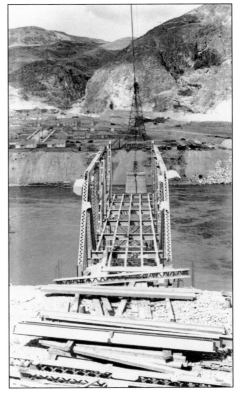

This July 8, 1935, photograph shows the government highway bridge under construction with some of the floor system and truss panels framed and a stack of structural steel members in the foreground. The bridge's piers were built by Western Construction Company, and the bridge was erected on the piers by J. H. Pomeroy Company of San Francisco. (Courtesy Washington State Archives.)

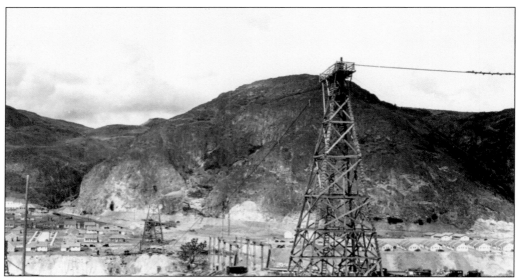

This photograph, also dated July 8, 1935, shows the towers and overhead cables that enabled a high-lead system to deliver structural steel members to be installed on the government highway bridge, similar to that used by MWAK on their temporary timber bridge. A platform with handrails is provided at the top of the towers. (Courtesy Washington State Archives.)

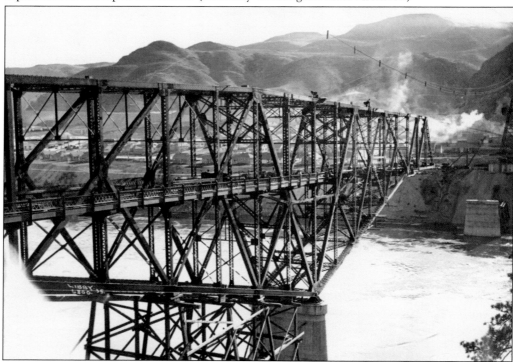

This 1935 photograph shows the government highway bridge spanning from the east abutment to the east pier and extending toward the west pier. Falsework is still present under the east span, and the high-lead system is visible overhead. The bridge's ornate steel handrail is visible at the level of the highway deck. (Courtesy Washington State Archives.)

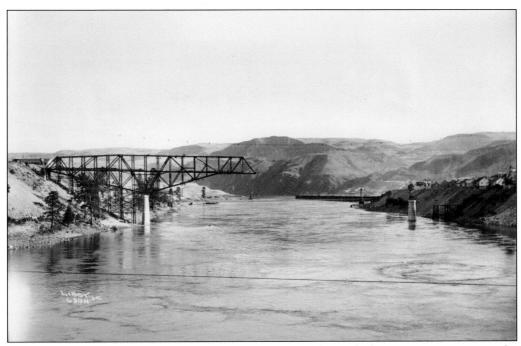

This 1935 photograph shows the government highway bridge with the east portion nearing the center of the main span, while the west portion has just been started. A small amount of falsework is visible between the west abutment and the west pier. Upstream, the west-side cofferdam for Grand Coulee Dam is visible. (Courtesy Washington State Archives.)

The east pier of the government highway bridge tipped toward the west, making it impossible to install the last steel between the east and west parts of the bridge. This January 30, 1936, photograph shows the cofferdam, which was pumped out to give workers relatively dry access to remove unstable earth around the pier, ease the pier into position, and encase it in concrete. (Courtesy Washington State Archives.)

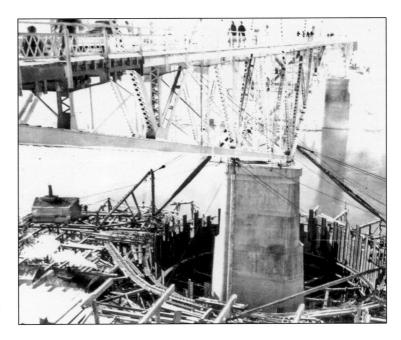

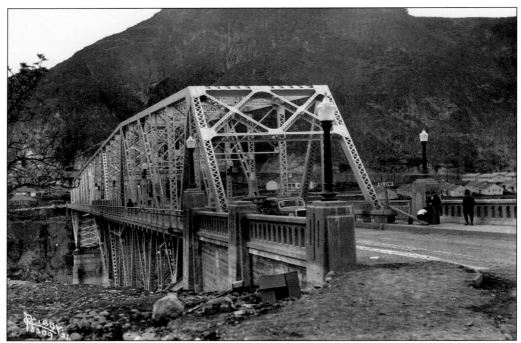

This 1936 view shows the completed government highway bridge carrying both pedestrian and vehicle traffic. This bridge is 1,066 feet long, with a 950-foot-long steel cantilever truss and 550-foot main span with two traffic lanes and two sidewalks. A concrete handrail and ornate lighting is provided at the end of the bridge. (Courtesy Washington State Archives.)

The Grand Coulee Highway is shown in this 1934 photograph. To aid with dam construction, the State of Washington regraded, widened, and hard-surfaced existing highways leading to Grand Coulee, and the government built a hard-surfaced road from the Grand Coulee to the dam site. An electric transmission line, operating at 110,000 volts, was also built from Coulee City to Mason City, a distance of 31 miles. (Courtesy Washington State Archives.)

# *Three*

# BUILDING
# THE DAM

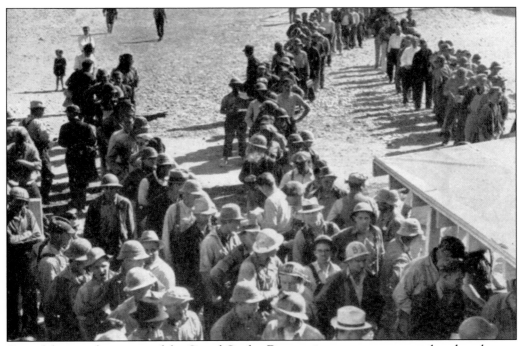

One of the stated purposes of the Grand Coulee Dam project was to put unemployed workers to work. This photograph shows a portion of the MWAK workers in line to collect their pay. These workers were a small part of the total employed building the dam. Between 1933 and 1943, well over 12,000 workers worked at the dam, with maximum employment estimated at 7,400 jobs at the same time. Workers were allowed a maximum of 8 hours per day and 40 hours per week. From 1933 through the end of 1941, the Department of the Interior estimated the total payroll at $54 million. Of those who worked on the dam, 57 percent were single, 60 percent were younger than 30 years, 40 percent were unskilled, and they represented every state in the union. More of the dam workers came from King County, Washington, than any other county nationwide. One measure of the dam's cost—fatalities—is unclear, but the records of reporter Hubert Blonk claimed that 72 workers perished building the dam. (Courtesy author.)

This undated portrait shows the Bureau of Reclamation's field engineer for Grand Coulee Dam, Alvin F. Darland, the primary assistant to the bureau's chief construction engineer Frank Banks. Darland worked on Grand Coulee Dam through construction and remained as a supervisor at the dam for many decades. (Courtesy Washington State Archives.)

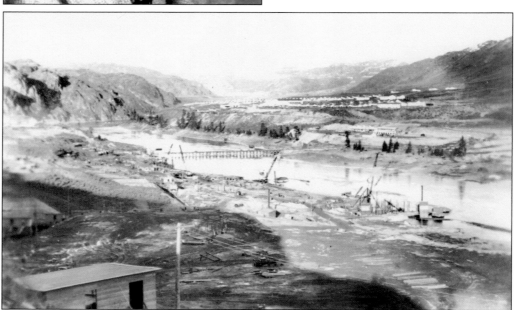

This 1935 New Year's Day scene shows the first day of driving sheet pilings for Grand Coulee Dam's west cofferdam. MWAK saved millions of dollars by diverting the river with cofferdams and providing slots between parts of the growing dam rather than excavating a temporary river channel. In the background is a temporary bridge, which was washed out by an ice jam later in January. (Courtesy Washington State Archives.)

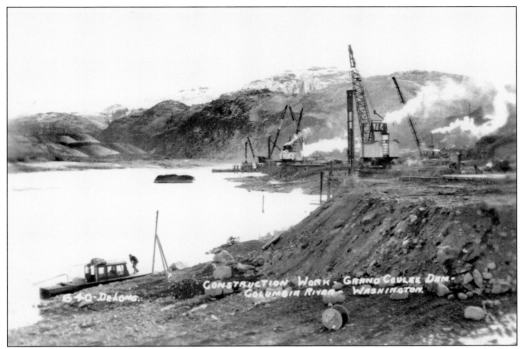

This photograph shows an early scene from the construction of the west cofferdam on January 1, 1935. Many of the sheet pilings were mangled as they were driven into 10-to-15-foot-diameter boulders, so many that pile driver operators would simply stop driving when a sheet encountered a boulder rather than destroy the sheet. In January 1935, over 2,500 workers were employed by MWAK. (Courtesy Washington State Archives.)

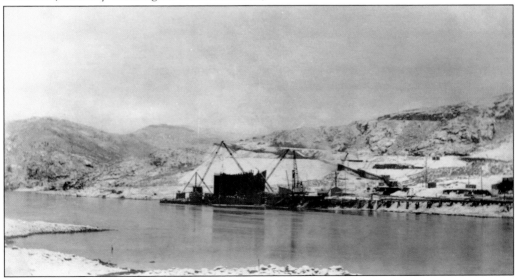

This January 8, 1935, photograph shows the southwest cell of the west cofferdam. MWAK worked three shifts driving sheet pilings and had installed 80,000 lineal feet of sheet pilings by mid-February. With spring floods coming, the contractor added 12 more steam hammers in order to install the rest of the total 290,000 lineal feet of sheet pilings. (Courtesy Washington State Archives.)

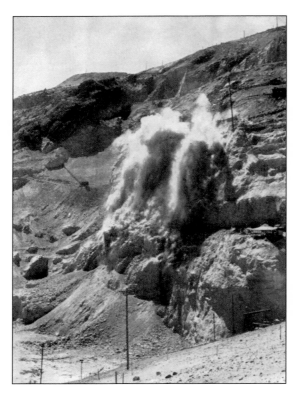

This undated photograph shows a blast as unsound rock is removed from solid bedrock, while a crane works in the background. Dynamite was tamped into drilled holes in unsound rock, and wires extended from electric blasting caps to a detonator. A whistle indicated that there would be blasting just before shift change, and the area was cleared of workmen and equipment before the blast. (Courtesy author.)

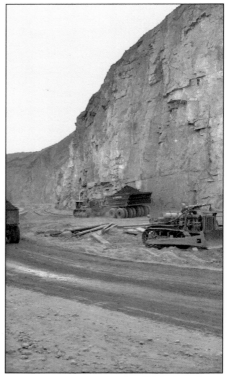

This undated scene shows a Caterpillar 30 tractor with bulldozer sitting parked while a Caterpillar D8, RD8, or Diesel 75 tractor equipped with a towing winch pulls a LeTourneau heavy-duty wagon full of excavated material along the base of a freshly exposed rock cliff. The Caterpillar D8 and RD8, which were introduced in 1935, are nearly indistinguishable from the earlier, less-powerful Diesel 75. (Courtesy author.)

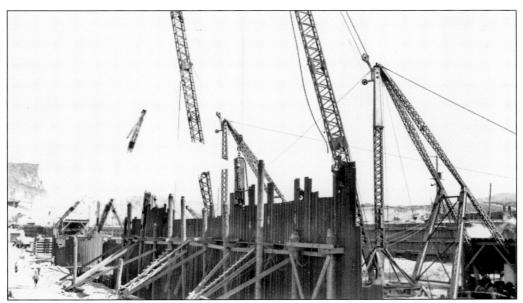

This April 14, 1935, photograph shows pile drivers at work on steel sheet pilings for the west cofferdam. The steam hammer, shown exhausting a blast of steam, is supported by a single block and wire rope from the derrick to the right. Also shown is the method of using timber piles and timbers to create a guide for the steel sheets. (Courtesy Washington State Archives.)

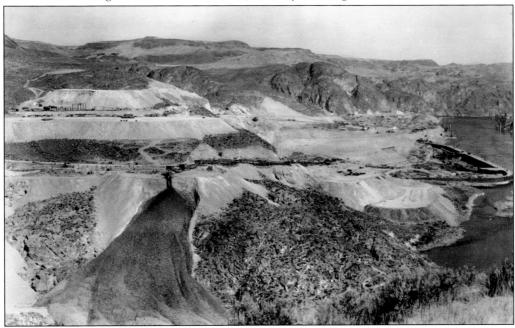

This undated photograph taken from a high vantage point shows the west cofferdam to the right, conveyors carrying excavated material to the left and upward, and a very large pile of excavated material to the left. Downstream from the cofferdam, MWAK's suspension foot bridge is visible, then the piers for the government's highway bridge, and finally MWAK's temporary highway bridge. (Courtesy Washington State Archives.)

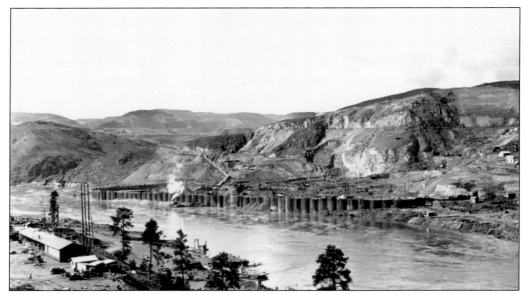

This scene, dated April 23, 1935, shows the west cofferdam in high water. The last sheet piling was driven to bedrock in the west cofferdam on Saturday, March 23, after less than 90 days of work. The conveyor system can be seen leading up toward Rattlesnake Canyon in the background. (Courtesy Washington State Archives.)

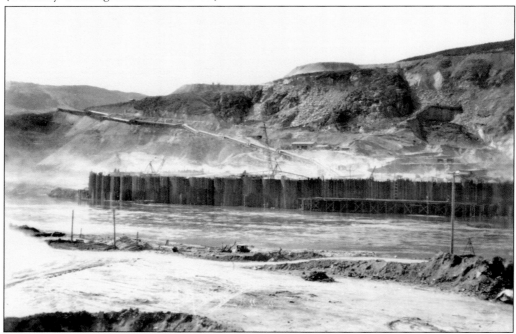

The west cofferdam is shown during high water in this June 7, 1935, photograph. On June 5, the Columbia River reached a flow of 308,000 cubic feet per second, prompting MWAK to haul in more earth and rocks to dump behind the cofferdam. The river reached a maximum flow of 344,000 cubic feet per second on June 19, more than 32 feet higher than normal. (Courtesy Washington State Archives.)

Sitting in a sling commonly known as a bosun's chair, supported by a single line of wire rope from a large crane, this rigger guides a section of steel sheet piling into place to be driven into the riverbed. The sheet pilings shown formed a part of the west cofferdam, later pumped out to enable relatively dry construction of the dam's western foundation. (Courtesy author.)

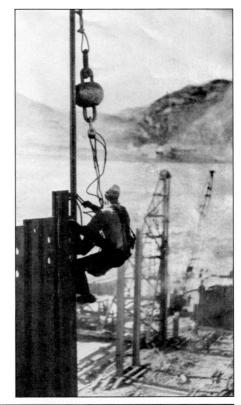

A worker welds steel sheet pilings in this 1935 photograph. The sheet piling used at Grand Coulee Dam was typically 15 inches wide, weighed 38.8 pounds per foot, and came in lengths up to 80 feet. Critical welds such as those for penstock components were inspected by X-ray methods. (Courtesy Washington State Archives.)

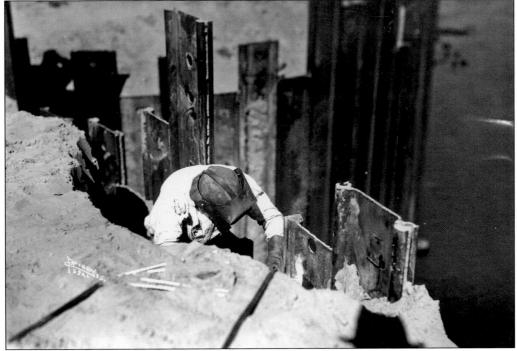

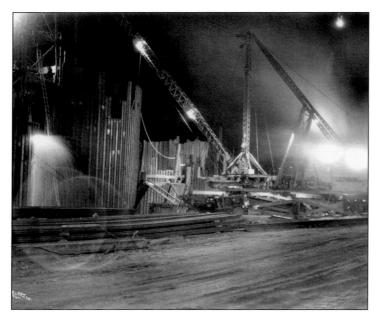

This 1935 night scene shows cofferdam work. At left, a welder works on sheet piling near a very tall ladder. In the foreground are stacks of steel sheet pilings, and toward the right, a derrick handles sheet pilings. By mid-summer 1935, the MWAK payroll reached 5,000 employees. (Courtesy Washington State Archives.)

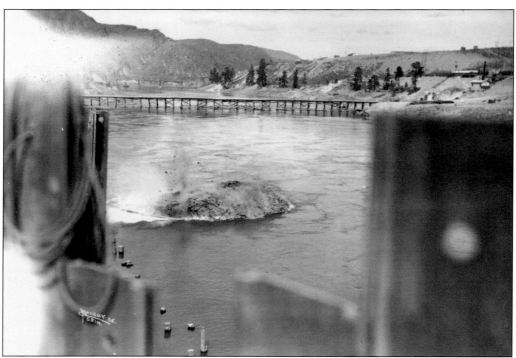

This 1935 photograph shows the surface of the Columbia River after an underwater blast near the west cofferdam. Evidently some underwater blasting was used to prepare the center channel for construction that would be done after the cofferdam was removed. MWAK's temporary highway bridge and the east pier for the government's highway bridge are visible down the river. (Courtesy Washington State Archives.)

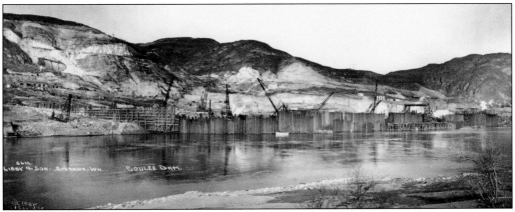

This 1935 view shows the west cofferdam with cranes working behind it, as sheet pilings are lengthened for high water. The trestle in front of the cofferdam supports rails for an improvised gantry equipped with McKiernan-Terry pile hammers, built to drive a group of sheets a few feet in succession rather than each sheet completely at one time, and to relieve a shortage of cranes. (Courtesy Washington State Archives.)

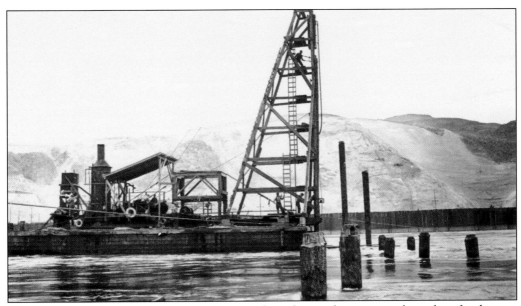

This July 15, 1935, scene shows a pile driver with workmen aligning a timber piling for driving. These timber pilings may have been for the timber bridge for the conveyor of excavated material or for the east cofferdam. The pile driver was improvised by mounting a large steam donkey engine, a steam hammer, and a timber tower on a barge. (Courtesy Washington State Archives.)

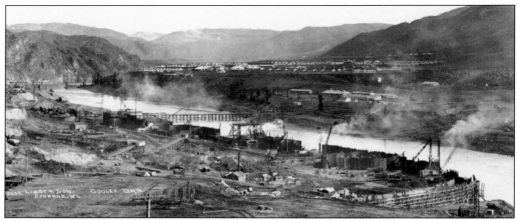

This 1935 photograph shows the excavation and continuing cofferdam work behind the west cofferdam it was raised and strengthened for high water. The timber gantry straddles the circular cells near the center of the scene, riding on steel rails and substituting for several cranes. (Courtesy Washington State Archives.)

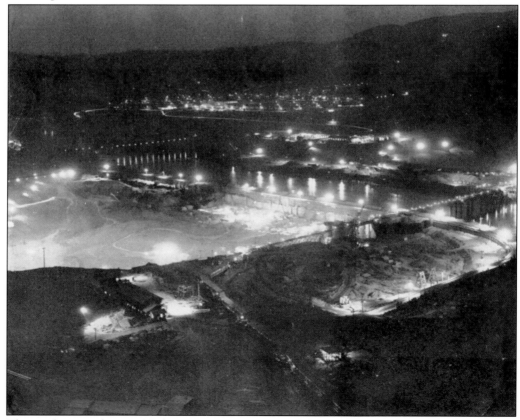

This night view from 1935 shows construction activity at Grand Coulee Dam. Lighting was provided for a variety of work activities performed day and night, especially excavation behind the west cofferdam. Lighting is also visible on the trestle carrying the conveyor across the river and on the conveyor itself leading into the foreground. (Courtesy author.)

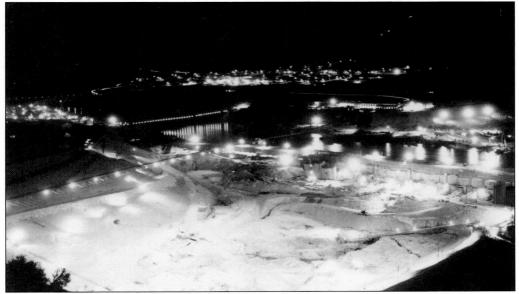

This October 3, 1935, night view shows the well-lighted excavation behind the west cofferdam. The lights are on in MWAK's undoubtedly busy shops on the east side of the Columbia River as well. Both Engineer's Town at left and Mason City across the river are illuminated well by street lighting. By October 31, 1935, six million man-hours had been expended and fatal accidents totaled 12. (Courtesy Washington State Archives.)

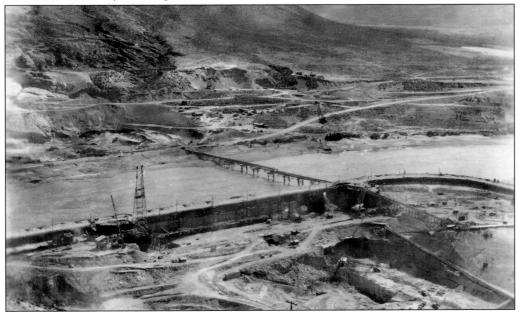

This photograph shows excavation work progressing behind the west cofferdam and a temporary timber bridge crossing the Columbia River near the site of the dam. The timber bridge carries a conveyor across the river, meeting a trestle behind the cofferdam. Also visible is the partially completed west main tower for the aggregate conveyor's suspension bridge being built behind the cofferdam. (Courtesy Michael Fairley.)

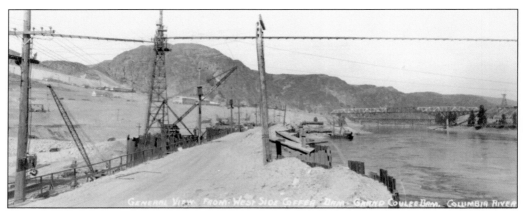

This 1935 photograph shows the top of the earthen fill behind the west cofferdam. To the left is the excavation for the foundation of the dam. Just to the right of the sheet pilings are three large pipes, which are the discharges for the pumps that remove water from the excavation. In the background, the government highway bridge has been partially painted. (Courtesy author.)

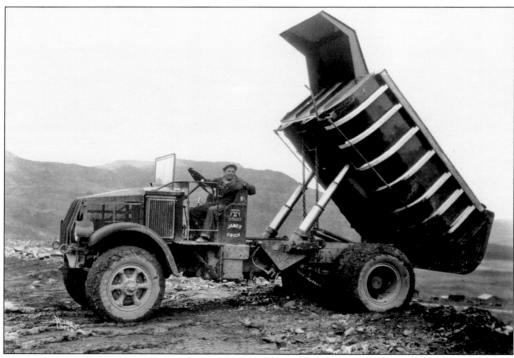

This photograph shows a Mack Model AP Super-Duty truck, belonging to James Crick, working at Grand Coulee Dam. Designed to carry payloads of up to 15 tons and powered by a Mack 150-horsepower, six-cylinder engine, this truck had pneumatic tires, Westinghouse air brakes, and a large hydraulic dump hoist. The total excavation required to expose bedrock for the dam was estimated at 12 million cubic yards. (Courtesy Washington State Archives.)

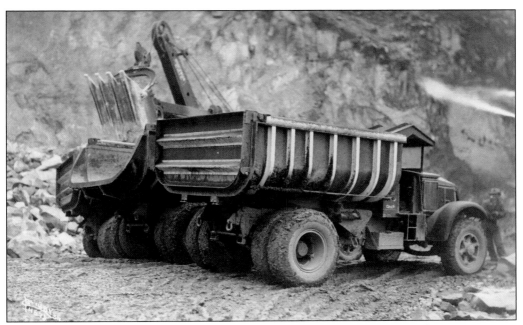

This photograph shows one of James Crick's Mack Model AP Super-Duty trucks waiting as one of MWAK's Bucyrus-Erie electric shovels loads another heavy-duty truck. These trucks were a refinement of the custom-built Model AP Super-Duty trucks Mack supplied for the construction of Hoover Dam in 1932, which had solid rubber tires. (Courtesy Washington State Archives.)

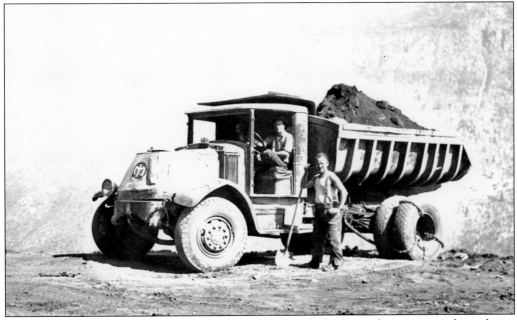

This well-worn Mack Model AP, belonging to an unidentified operator, has improvised tire chains for improved starting and stopping. The doors have been removed from the cab, probably in an effort to reduce the temperature inside. The missing headlight and bent hood and fender attest to rough usage. (Courtesy Washington State Archives.)

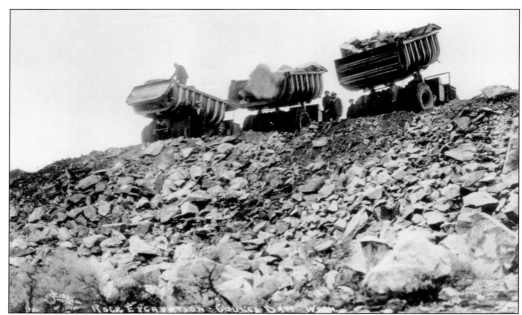

This dramatic perspective from a downhill viewpoint shows James Crick's Mack Model AP Super-Duty trucks dumping rocks and boulders. These large trucks augmented the conveyor system and added flexibility since they could be loaded or unloaded away from the conveyor system. The top speed of these trucks was probably around 30 miles per hour, depending on tire size and final drive sprocket options. (Courtesy Washington State Archives.)

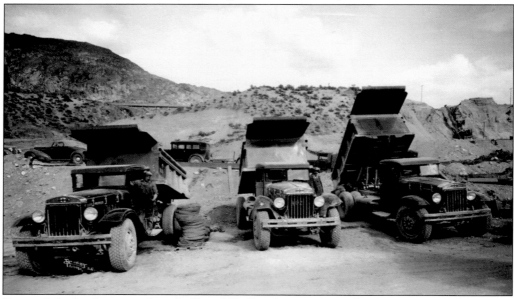

Some of the hauling was done by David H. Ryan's International Harvester Model A7 or A8 trucks with rock boxes and hydraulic hoists, shown in this 1935 photograph. Ryan contracted for 2.04 million cubic yards of excavation work in addition to building the 32-mile railroad to the dam site. These trucks were equipped with enclosed cabs, bumpers, and brush guards. (Courtesy Washington State Archives.)

The 1935 Ford trucks shown in this photograph were built for much more modest loads than the Mack and International trucks working at Grand Coulee Dam. These Fords had a single-cylinder hydraulic hoist and their rock boxes had no cab guard. It must have been rough when the shovel unloaded a full bucket into the truck. (Courtesy Washington State Archives.)

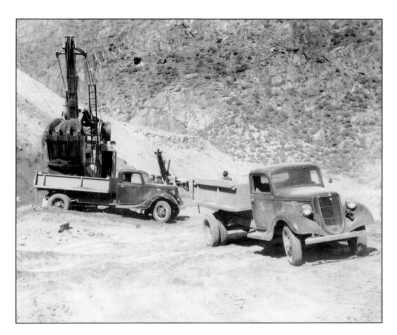

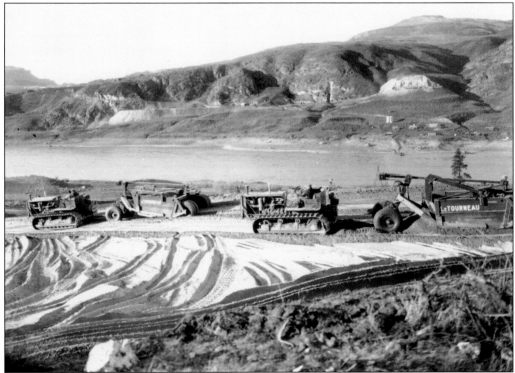

This undated photograph shows Caterpillar D8, RD8, or Diesel 75 tractors pulling LeTourneau scrapers, removing loose material. The tractors are equipped with a towing winch and radiator guard. An unknown but clearly significant number of Caterpillar D8, RD8, and Diesel 75 tractors helped to build Grand Coulee Dam. (Courtesy Washington State Archives.)

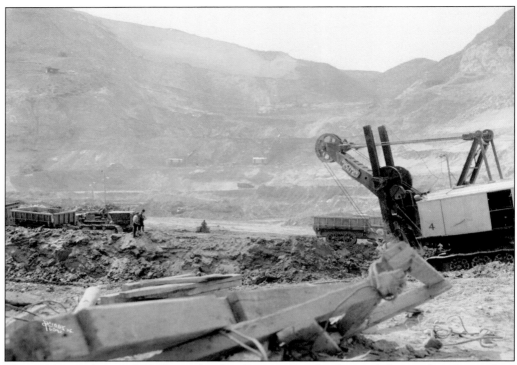

This 1935 view shows MWAK's number four Bucyrus-Erie 5-cubic-yard electric shovel at work in an excavation. Heavy-duty trailers on tracks, pulled by Caterpillar D8, RD8, or Diesel 75 tractors, wait to deliver the excavated earth and rock to the conveyor system, which carried the material to Rattlesnake Canyon. (Courtesy Washington State Archives.)

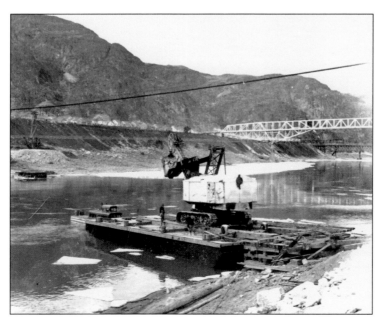

This March 26, 1936, photograph shows MWAK's No. 4 Bucyrus-Erie 5-cubic-yard electric shovel being loaded on a barge to be moved. At the right is a loading ramp built of timber cribbing. The deck of the barge is protected by two large timbers, and a tug steadies the barge. (Courtesy Washington State Archives.)

This crew is using compressed–air powered jackhammers to drill into rock in the cliffs about 500 feet above the west side of the Columbia River. A combination of drilling and blasting was used to expose sound rock. Some of the workmen are supported by slings rigged as bosun's chairs, and some of them are wearing hardhats. (Courtesy author.)

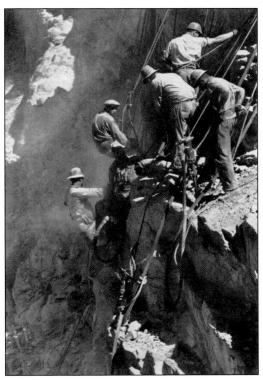

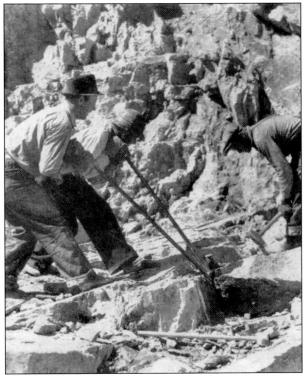

The final clearing of loose rock from the bedrock was done by hand using sledgehammers, wedges, and crowbars, as shown in this undated photograph. The cracks in the unsound rock were split with wedges, and if the wedges were not enough, crowbars were employed to help break the rock. (Courtesy author.)

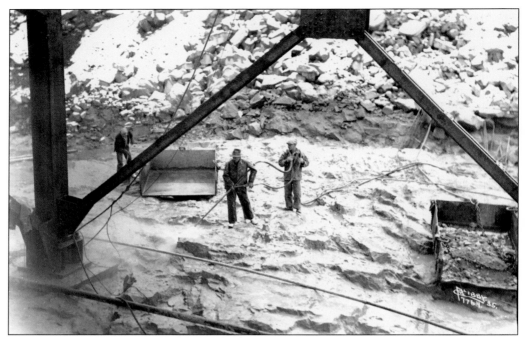

The bedrock was washed after sandblasting, as shown in this 1935 scene. The workmen washing the bedrock are wearing rain gear and handling a nozzle that mixes high-pressure water and compressed air. After cleaning, a 1/2-inch-thick layer of grout was placed on the bedrock. The cost of bedrock preparation was estimated at 75¢ per square foot. (Courtesy Washington State Archives.)

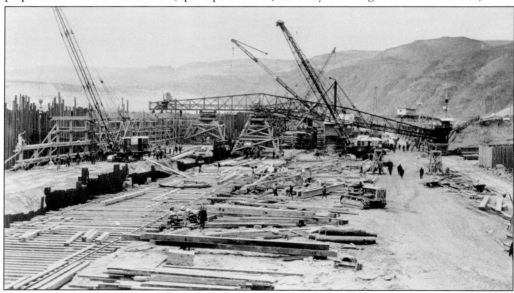

This photograph shows parts of a hammer-head crane under construction behind a cofferdam. The large truss being assembled in the center is the crane's boom, and the 28-foot-gauge tracks in front will carry the crane as it is assembled. The bottom of the boom will be straight when completely assembled. These cranes had a capacity of at least 11 tons and reach of 115 feet. (Courtesy Washington State Archives.)

A common type of gantry used on Grand Coulee Dam was the Clyde Wylie, illustrated in this 1935 photograph carrying a steam hammer to drive sheet pilings in a cofferdam. The Clyde Wylies straddled two sets of tracks, providing an improvised bridge crane. Rungs were nailed to the timbers to provide access to the platform atop the gantry. (Courtesy Washington State Archives.)

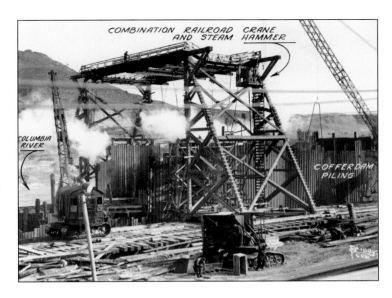

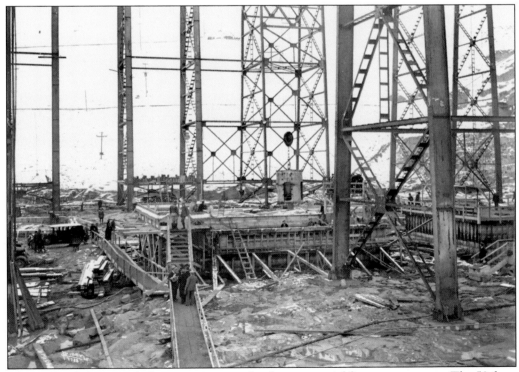

This undated photograph shows preparations for the ceremonial first concrete pour. The 50-foot-square block forms selected for the pour are being decorated with bunting amid the steel legs of the high and low trestles. The 4-cubic-yard bucket used to carry the wet concrete from the mixing plant to the pour is visible, supported by a single block from an overhead crane. (Courtesy Washington State Archives.)

This photograph shows Washington governor Clarence D. Martin dressed up for the ceremonial first concrete pour in Block 16-G on the afternoon of December 6, 1935. Clarence D. Martin of Cheney was elected governor in November 1932, sharing in the success of fellow Democrat Pres. Franklin D. Roosevelt and his New Deal in Washington State. (Courtesy Washington State Archives.)

This December 6, 1935, scene shows Washington governor Clarence D. Martin in the block forms for the ceremonial first concrete pour, 60 feet below the level of the Columbia River behind the west cofferdam. The governor is using a large electric vibrator to help spread out one of the nine 4-cubic-yard bucket loads of wet concrete that he emptied. (Courtesy Washington State Archives.)

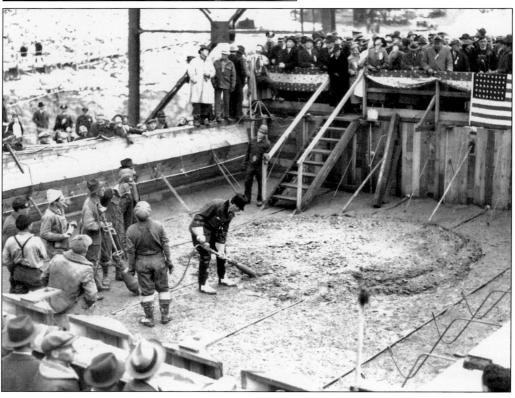

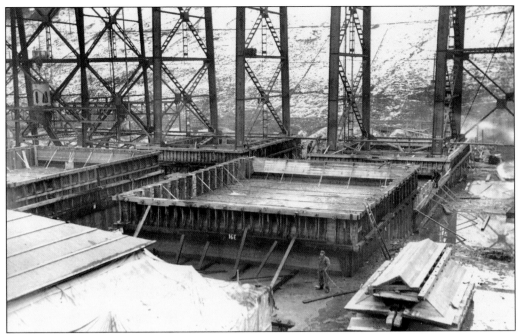

This undated winter photograph shows the 50-foot-square forms for block 16-E at an early, low level among the forms for other blocks. In the foreground, a set of forms is covered to keep the concrete from freezing while it cures. The blocks in the background are being cast around the steel trestle legs, which were left in place within the dam. (Courtesy Washington State Archives.)

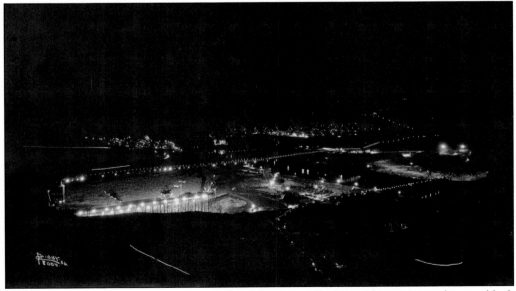

This 1936 night view shows construction behind the west cofferdam with gantries working on block pours from the high trestle, which is 1,024 feet above sea level. At the left end of the high trestle the Westmix plant is visible. Marked by lights are the river crossings of the excavated material conveyor at right, the aggregate conveyor downstream, and the footbridge farther downstream. (Courtesy Washington State Archives.)

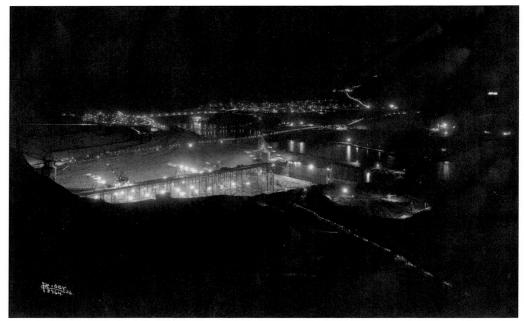

This 1936 photograph shows the high trestle extending from the Westmix plant toward the west cofferdam lighted for night work. Several hammer-head cranes and a whirley crane are visible on the trestle. The excavated material conveyor across the river has been destroyed, and the government highway bridge downstream is fully lighted. (Courtesy Washington State Archives.)

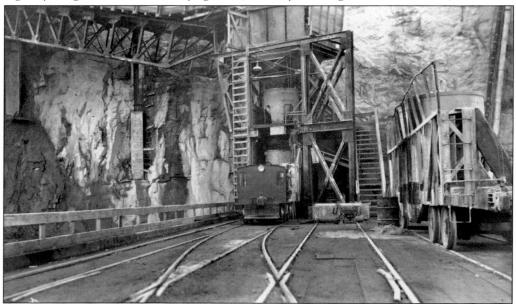

This 1936 photograph shows the top of the low trestle at its west end. At left, a steel truss supports the chute that carries wet concrete from the concrete plant to the 4-cubic-yard buckets, which were placed on a flatcar pulled by the 10-ton diesel-electric locomotive and shuttled to a waiting crane above the pour. A rope ladder leads down to supports below the chute. (Courtesy Washington State Archives.)

This January 30, 1936, view shows block forms and the low trestle. Most of he block pours contained enough concrete that the heat generated had to be removed by 10,120 gallons per minute of water cooled by a 2,440-ton refrigeration plant, circulating through 1-inch-diameter steel pipes placed before each pour. Cooling took three months and was monitored by thermometers embedded in the concrete. (Courtesy Washington State Archives.)

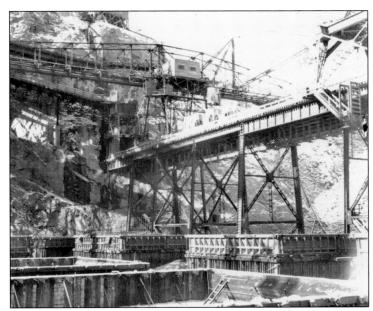

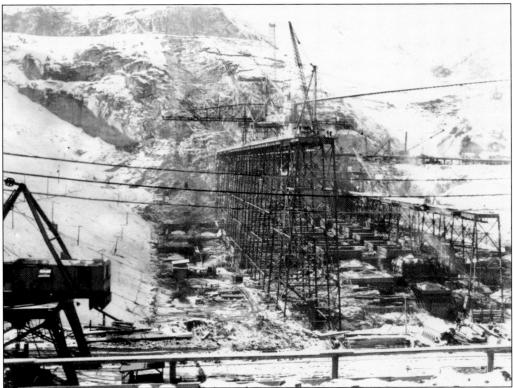

This photograph, dated February 4, 1936, shows the high and low trestles behind the west cofferdam and numerous blocks in various stages of forming and pouring. The whirley crane at left in the foreground rides on rails atop the west cofferdam. Several workers are visible on the end of the high trestle. (Courtesy Washington State Archives.)

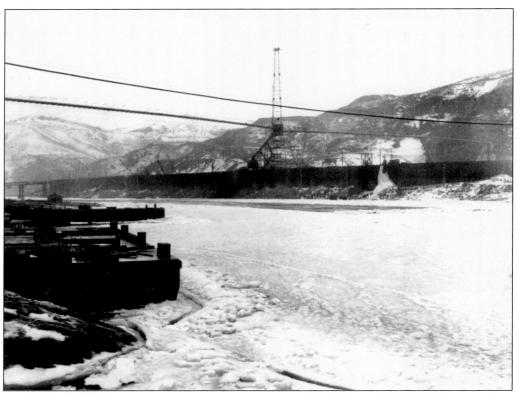

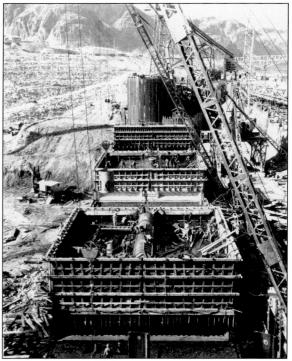

This February 26, 1936, photograph shows the Columbia River mostly frozen over. During January, MWAK used steam to heat the water used to mix concrete and the bedrock and 36 steel-framed canopies to protect freshly poured concrete from the cold. On January 31 and February 1, MWAK laid-off 2,000 concrete workers and waited for warmer weather, which came in March. (Courtesy Washington State Archives.)

This photograph, dated April 8, 1936, shows a concrete pour underway in block 40, located just behind the west cofferdam. Concrete surfaces were brushed with wire-brush brooms or sandblasted to remove a quarter inch off the surface, and the surface was dampened and covered with a half inch of grout. An electric shovel excavates behind the cofferdam at the left. (Courtesy Washington State Archives.)

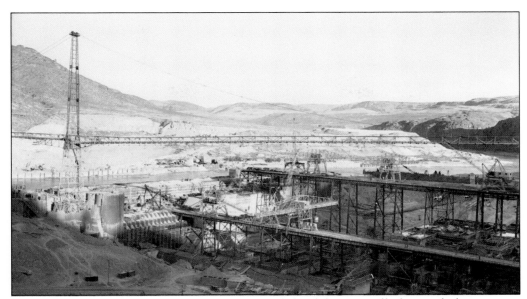

This undated photograph shows block construction behind the west cofferdam, with the aggregate conveyor suspension bridge overhead. The low trestle and high trestle are busy with numerous cranes at work. The hammer-head crane on the low trestle is hoisting one of the 4-cubic-yard concrete buckets from a gondola parked beneath. (Courtesy author.)

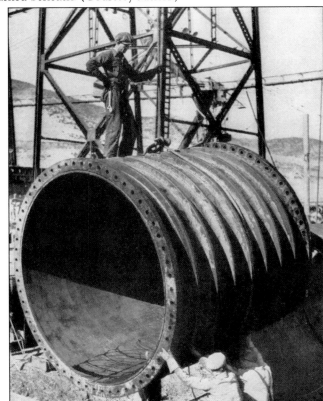

This undated view shows one of the semi-steel conduits that line the entrances of outlet tunnels. The conduits are provided to protect the concrete from wear and were carefully designed to minimize erosion because of the flow of water. The heavy ribs help strengthen the conduit and anchor it into the concrete. (Courtesy author.)

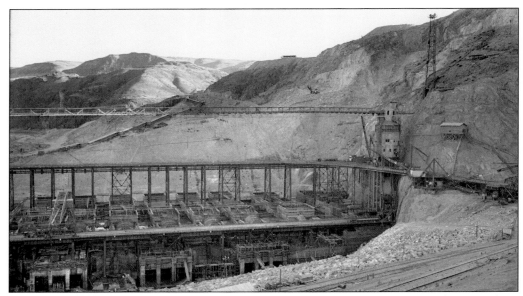

This undated photograph shows the west end of the dam under construction. At the top right is a clear view of the west end of the aggregate conveyor suspension bridge, showing the tower built on the rock cliff above the Westmix plant. An 11-inch-diameter pipe was installed on the bridge so that cement could be blown across by compressed air. (Courtesy author.)

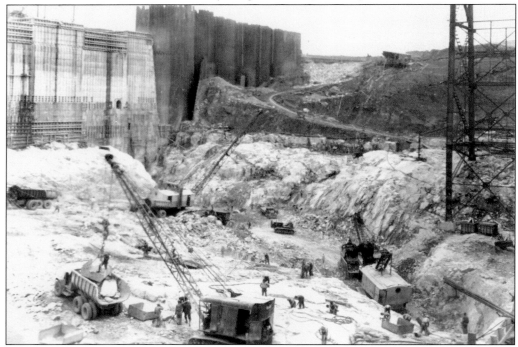

This June 18, 1936, photograph shows excavation work with numerous workmen, trucks, tractors, cranes, and power shovels behind the west cofferdam with the end of one of the trestles at the right. A section of concrete is prominent at the left, flanked by a high section of cofferdam and temporary earth fill. (Courtesy Washington State Archives.)

This August 5, 1936, view shows gondolas full of 4-cubic-yard concrete buckets being moved atop the low trestle behind the west cofferdam. To the left is the base for the west powerhouse, and to the right are the forms for the penstocks. The penstocks are 18-foot-diameter tubes that deliver flowing water to the turbines. (Courtesy Washington State Archives.)

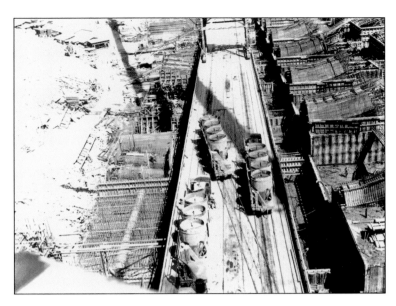

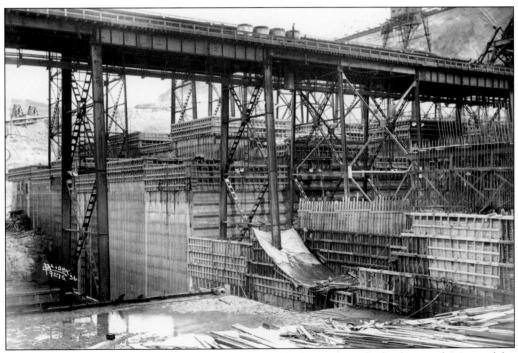

This 1936 photograph shows the low trestle with the high trestle in the background. Many of the blocks have been poured to medium height and the space between blocks filled with concrete. The forms for the blocks are "slip forms," which are moved up after each pour as the block becomes higher. (Courtesy Washington State Archives.)

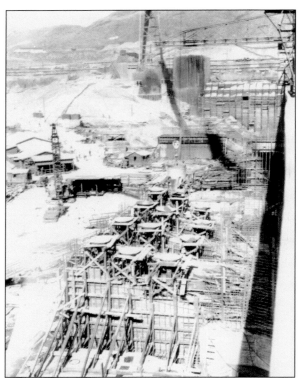

This August 5, 1936, photograph shows a concrete pour in block P-5-B in the base for the west powerhouse. The funnel-shaped devices are tremie tubes, which are apparently being used to avoid having the wet concrete free fall into the forms where the 4-cubic-yard buckets could not fit to pour directly. Steel reinforcement for the concrete wall is visible to the right. (Courtesy Washington State Archives.)

This September 8, 1936, scene shows part of the 1,100-foot timber cross-river cofferdam being launched from the downstream east bank of the Columbia River. The cofferdam is being pushed by a Caterpillar D8, RD8, or Diesel 75 tractor equipped with a bulldozer blade. The MWAK payroll included 5,300 workers in September. (Courtesy Washington State Archives.)

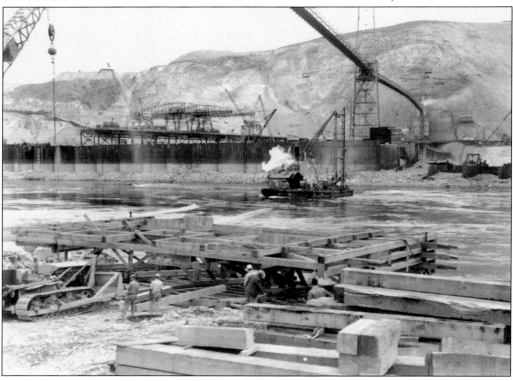

This September 25, 1936, photograph shows timber trusses used to support the cofferdam for block 40. Additional trusses were added below as the excavation became deeper. When forms could be removed after a concrete pour, earth fill was placed between the sheet pilings and the concrete, and trusses were removed from the bottom up as the concrete became higher. (Courtesy Washington State Archives.)

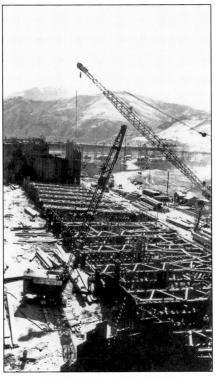

This September 30, 1936, scene shows the base of the dam taking shape behind the west cofferdam with the high trestle to the left, the Westmix plant on the cliff in the background, and the low trestle to the right. Several whirley cranes are working serving concrete pours on both trestles, and a 10-ton diesel-electric locomotive pulls a gondola at right. (Courtesy Washington State Archives.)

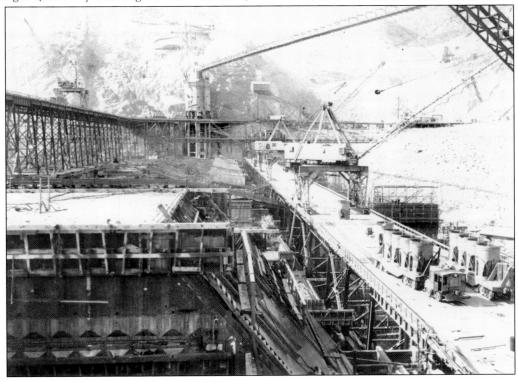

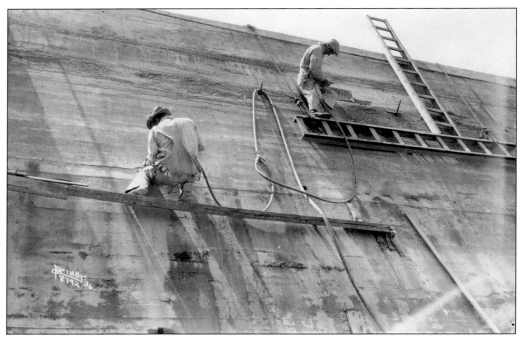

This 1936 photograph shows workmen repairing an exposed surface. Patching was done with grout packed into place by pneumatic hammers. The worker at left works from a doubled plank, and the worker at right works from a ladder suspended from the top of the concrete. Forms for exposed concrete such as this were made with vertical-grain tongue-and-groove fir lumber. (Courtesy Washington State Archives.)

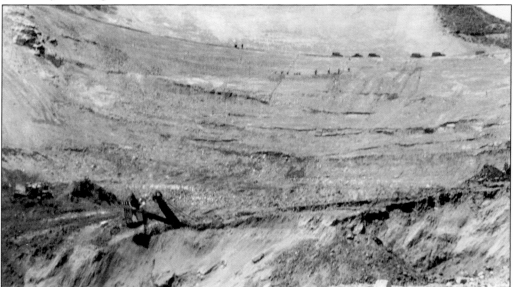

This May 23, 1936, photograph shows some of the landslides and cracking earth that plagued excavation efforts on the east side of the river. A number of vehicles and workers are visible at the top of the embankment, presumably examining the situation, while a power shovel works below. (Courtesy Washington State Archives.)

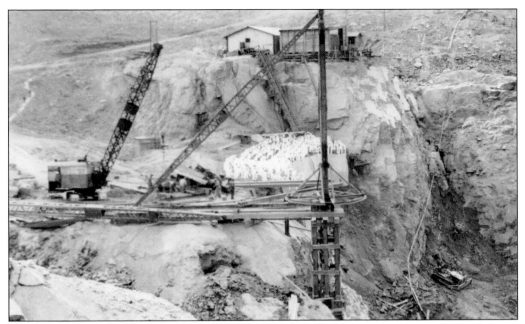

This October 30, 1936, photograph shows the freezing plant that was arranged to stabilize a particularly difficult 40-foot-by-100-foot area of embankment on the east side of the river. The white, bent tubes sticking out of the embankment near the center are the piping loops driven into the clay to freeze the unstable earth. (Courtesy Washington State Archives.)

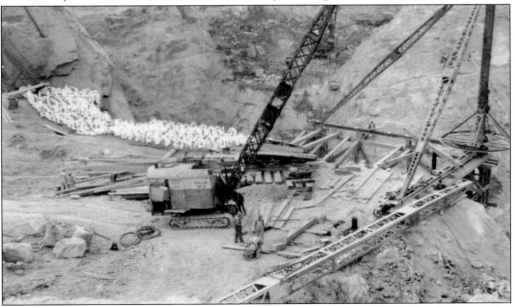

This October 30, 1936, view shows the 102 pipes that were driven 25 feet into the clay to stabilize the embankment. There was a total of 3 miles of the 3-inch-diameter steel piping, placed at 30-inch intervals to carry super-cooled brine. The 80-ton freezing plant cost a total of $30,000 and saved an estimated $100,000 of extra excavation that would otherwise have been necessary. (Courtesy Washington State Archives.)

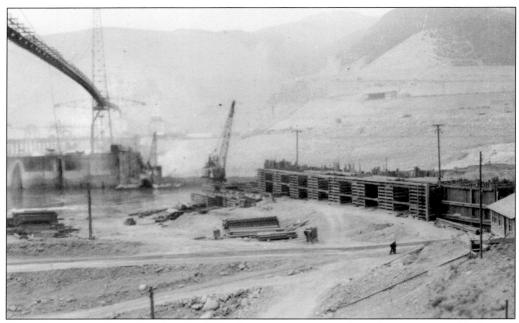

This photograph, dated October 30, 1936, shows construction of the downstream cofferdam on the east bank of the river. This portion of the east cofferdam was constructed with timber cribbing behind steel sheet pilings. The timber cribbing for the east cofferdam required 3 million board feet of heavy timbers. (Courtesy Washington State Archives.)

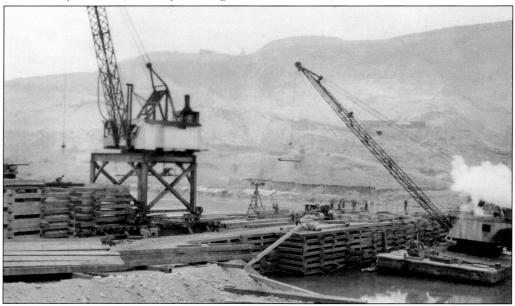

This October 30, 1936, photograph shows cross-river cofferdams being extended and connected after being placed in the river. Fill material has been dumped into the cofferdams, helping to hold them in place and allowing the Caterpillar tractor to drive on them. At the left is a whirley crane used on the cofferdams, riding on rails and deck-supported by timber pilings. (Courtesy Washington State Archives.)

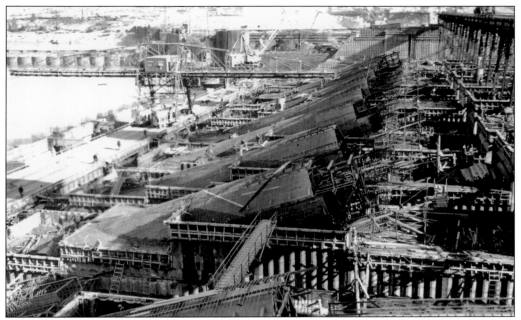

This November 6, 1936, view shows the elaborate penstock forms progressing between the high trestle and the low trestle. A hammer-head crane serves a concrete pour on the low trestle, and the blocks closest to the west cofferdam are visible in the background. The west cofferdam is visible in the left background. (Courtesy Washington State Archives.)

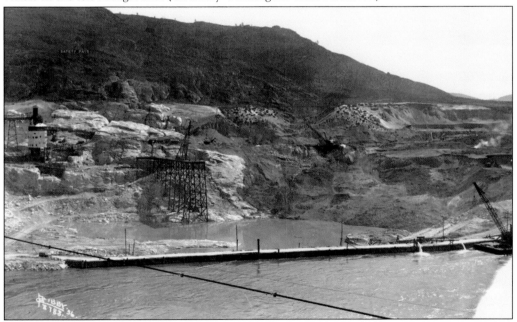

This 1936 photograph shows the early, low east cofferdam being pumped out. The low cofferdam had only been designed to keep the river out until peak flood waters arrived. To the right, near the crane on a barge, are two discharge streams from the pumps that are dewatering the excavation. The trestle does not reach the Eastmix plant yet. (Courtesy Washington State Archives.)

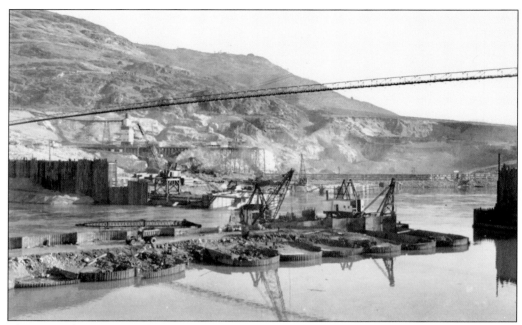

This November 20, 1936, photograph shows a much larger east cofferdam under construction across the river, while earth and rock fill is removed from the downstream portion of the west cofferdam. On November 5, gates in the west cofferdam were opened, allowing water to flow through the 32-foot-wide channels left between blocks. (Courtesy Washington State Archives.)

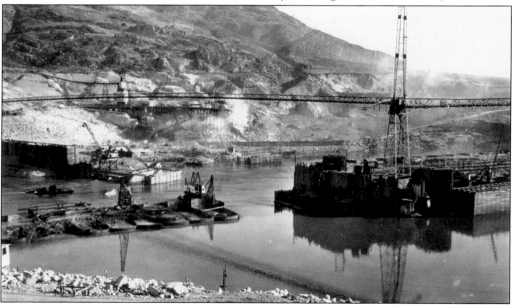

This November 21, 1936, photograph shows cranes removing piles from the downstream part of the west cofferdam. The cross-river cofferdam in the river will be leveled up and filled with earth and rock. As the upstream and downstream parts of the west cofferdam were removed, more cross-river cofferdams were placed to force the flow to the west. MWAK issued 6,347 paychecks just before Thanksgiving. (Courtesy Washington State Archives.)

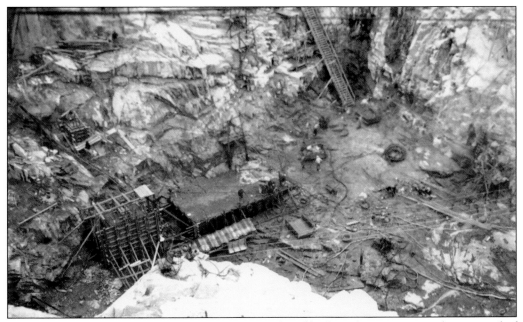

This November 27, 1936, view shows concrete work in block 69-A in a pit near the east end of the dam. Forms for trestle leg footings are visible to the left, and numerous compressed-air lines are visible on the floor of the pit. In the background, a stairway has been provided for access into the pit. (Courtesy Washington State Archives.)

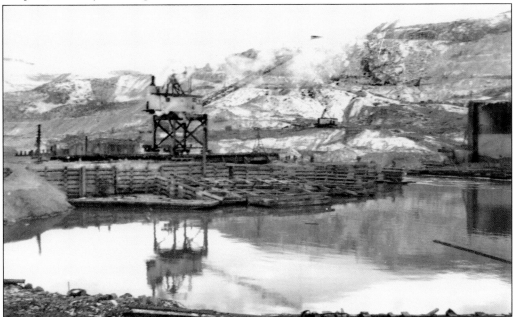

This photograph, dated December 10, 1936, shows timber cribbing for the upstream diversion one day after the last crib was placed in the downstream diversion. In the foreground are a barge and some cribbing sections waiting to be leveled and filled. By December 12, the entire river flowed through the diversion. (Courtesy Washington State Archives.)

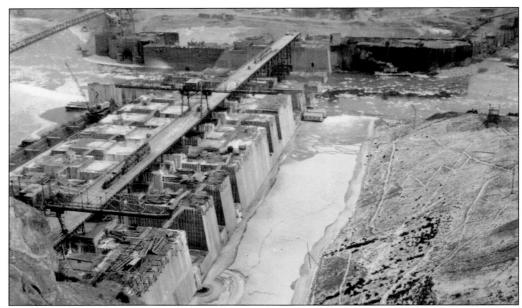

This January 8, 1937, view looking toward the east shows west-side blocks approaching the height of the high trestle, which now extends to the east cofferdam. Several diesel-electric locomotives haul gondolas loaded with concrete buckets on the trestle among the hammer-head cranes. Also visible is a layer of ice on the pool along the upstream side of the dam. (Courtesy Washington State Archives.)

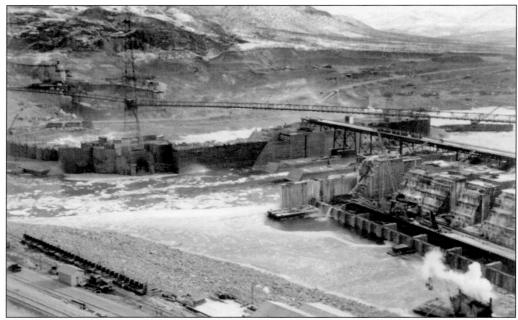

This January 8, 1937, photograph shows the east cofferdam, the Columbia River flowing through the diversion channels, some walls of the west powerhouse, the high trestle across the diversion channel, and the blocks of the west side of the dam reaching higher. In the distance to the left, the Eastmix plant and the east trestle are visible. (Courtesy Washington State Archives.)

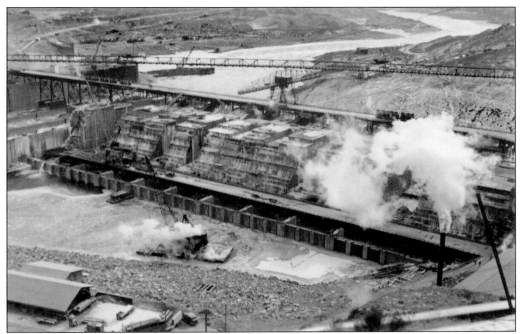

This January 8, 1937, photograph shows the dam's structure nearly at the height of the low trestle. The west cofferdam has been removed, filling a pool in front of the powerhouse, and the high trestle has been extended toward the east. A barge-mounted crane is working in the foreground. (Courtesy Washington State Archives.)

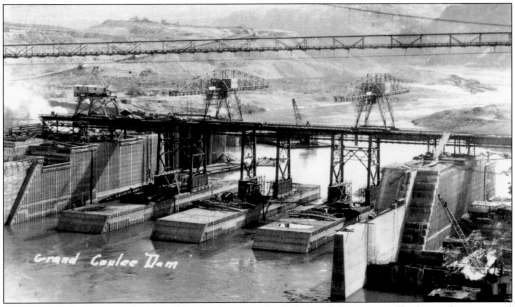

This undated photograph shows blocks that were built behind the west cofferdam, after removal of the west cofferdam when the full flow of the Columbia River passed through the diversion channels. The suspension bridge carrying aggregate to the west-side mixing plant (Westmix plant) is visible overhead in the foreground. (Courtesy author.)

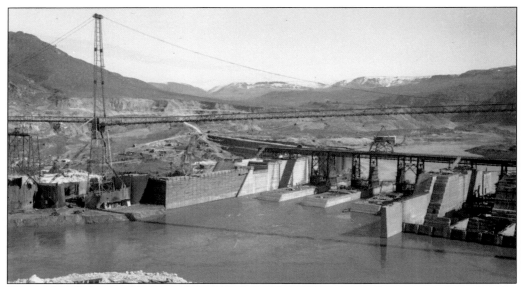

This undated photograph shows the timber cribs of the downstream diversion in place with the Columbia River flowing through the diversion channels. On January 9, 1937, the river froze completely. On January 11, the bed of the river became visible after six days of pumping water from the east cofferdam. (Courtesy author.)

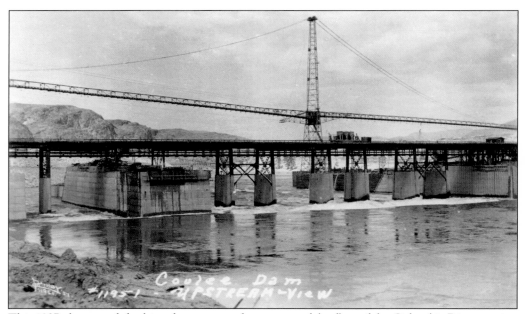

This 1937 photograph looking downstream shows some of the flow of the Columbia River passing through openings left between blocks. The openings were provided for this purpose when the blocks were built behind the west cofferdam, which has been removed. Cross-river cofferdams are obstructing the flow, forcing water to pass through these openings. (Courtesy author.)

This March 29, 1937, photograph shows the ruptured cell F-6 of the east cofferdam at block 40, later repaired with a retaining wall and fill. A similar, but more serious failure on March 18 followed heroic efforts on March 17 to stop a leak with rock, earth, brush, hay, and mattresses, and was repaired with additional sheet pilings and fill. Leakage reached 29,000 gallons per minute. (Courtesy National Archives.)

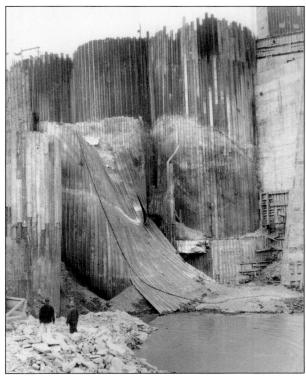

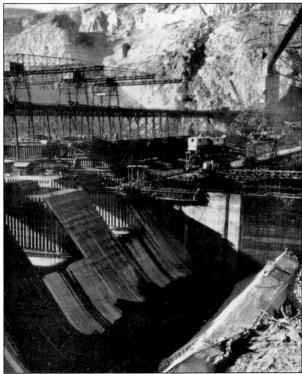

This photograph illustrates elements of the dam built behind the west cofferdam, including the base for the west powerhouse and part of the spillway section of the dam. The low trestle is visible to the right, and the high trestle and the Westmix plant are visible in the background. (Courtesy author.)

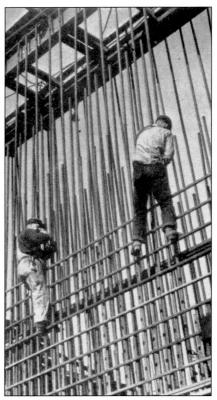

This undated scene shows workmen tying large steel reinforcing bars using steel wire to help to hold the bars in their proper locations during the concrete pour. The workmen cling to the bars with none of the safety gear taken for granted today. Over 75 million pounds of reinforcing steel was consumed in building the dam. (Courtesy author.)

The repaired east cofferdam is shown to the left in this aerial photograph dated April 16, 1937. Foundations for the dam were built within the west cofferdam and then a portion of the west cofferdam was removed. This allowed the river a place to flow while the east cofferdam was built. The remaining portions of the west cofferdam are now part of the east cofferdam. (Courtesy Michael Fairley.)

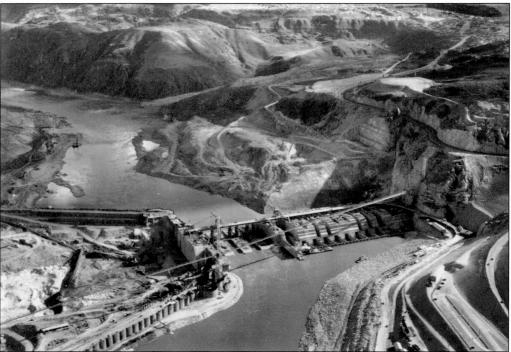

This undated scene shows the east-side concrete mixing plant (Eastmix plant) and the trestle at 1,024 feet above sea level as seen from the viewing gallery. As many as 5,000 visitors used this facility on some Sundays, with many of the tourists traveling the 97 miles from Spokane. During the 1950s, nearly 300,000 people visited the dam each year. (Courtesy author.)

This photograph, looking toward the northwest, shows the concrete structure of the dam rising within the east cofferdam. Two tramways carried the cranes that delivered concrete and materials to the east part of the dam. By June 1937, the dam contained 3.25 million cubic yards of concrete, and on August 28, workmen poured a record 15,844 cubic yards of concrete, bringing MWAK's monthly total to 377,133 cubic yards. (Courtesy Michael Fairley.)

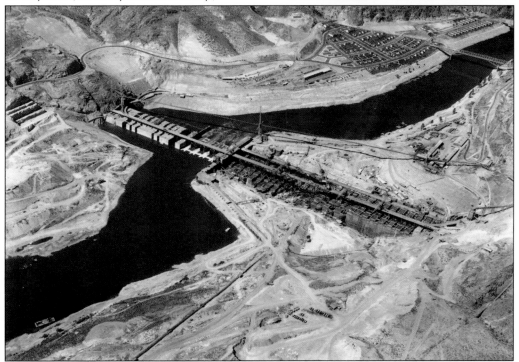

This October 2, 1937, photograph shows Pres. Franklin D. Roosevelt touring Grand Coulee. In a speech during the visit, the president stated "this is the largest structure, so far as anybody knows, that has ever been undertaken by man in one place. Superlatives do not count for anything because it is so much bigger than anything ever tried before that there is no comparison." (Courtesy Ray Hobson.)

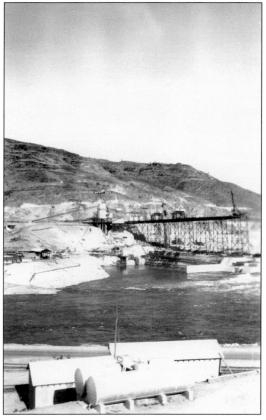

This undated photograph shows construction of the east portion of CBI's new high trestle over 200 feet above the dam foundation and 1,180 feet above sea level. The newly elevated Eastmix plant is visible at the end of the trestle. The trestle was assembled by oxy-acetylene welding, which likely accounts for the two large tanks in the foreground. (Courtesy author.)

This undated photograph shows construction of the west portion of the CBI (Consolidated Builders, Inc.) trestle, with a railroad-style crane placing steel members. The new high trestle was 3,600 feet long when completed. A walkway spans the channels provided for river flow between blocks. When MWAK handed the dam over to CBI, the cost of contract work totaled $39,430,000. (Courtesy author.)

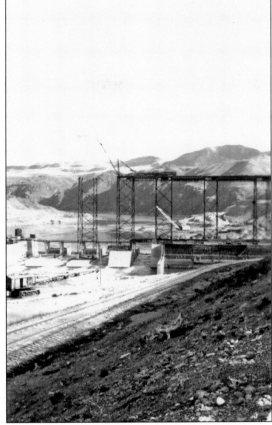

This 1938 view shows construction of both halves of the CBI trestle being erected by Bethlehem Steel. Portable gates are visible at the upstream end of the slots provided for river flow between the blocks. Numerous workmen are on the trestle working among equipment and construction materials. (Courtesy author.)

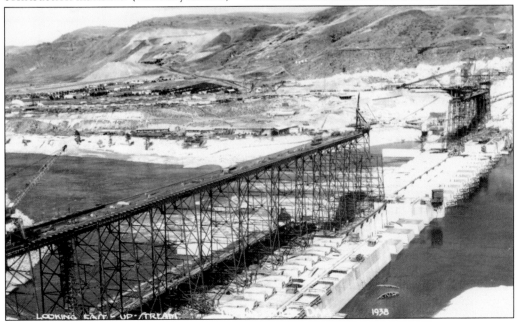

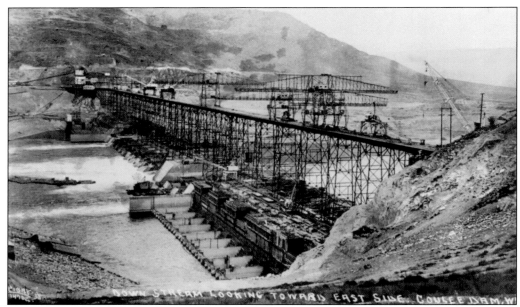

This 1938 photograph shows the dam site looking toward the east, with the CBI trestle extending clear across the Columbia River, the flow of the river passing through openings between blocks, and both the west cofferdam and east cofferdam removed. Consolidated Builders, Inc., a consortium headed by Henry J. Kaiser, began work on the dam in March 1938. CBI employment reached 1,665 workers by May 1938. (Courtesy author.)

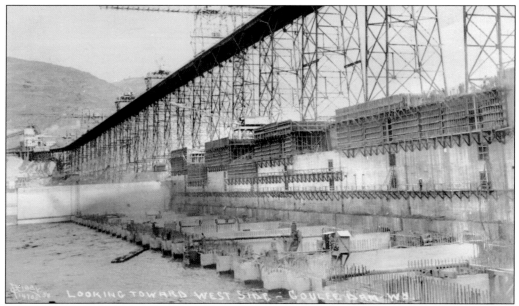

This 1938 photograph shows the CBI trestle with gantries on top. The new, high trestle required 5,700 tons of new steel and was completed by Bethlehem Steel on September 20, 1938. Contrary to the notation at the bottom of the photograph, this view is looking toward the east from the west side of the river. The Eastmix plant is visible to the left. (Courtesy author.)

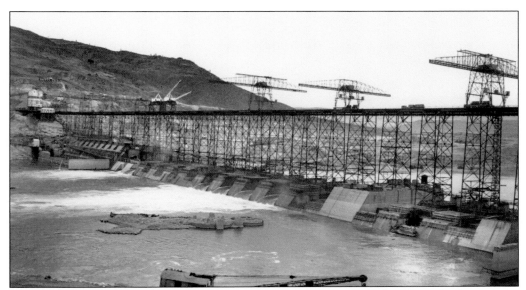

By the time this undated photograph was taken, the CBI trestle had been built, and the Westmix plant had been moved to the east side, doubling the capacity of the east-side concrete mixing plant. A portion of the east cofferdam is still visible in the river waiting to be removed. (Courtesy author.)

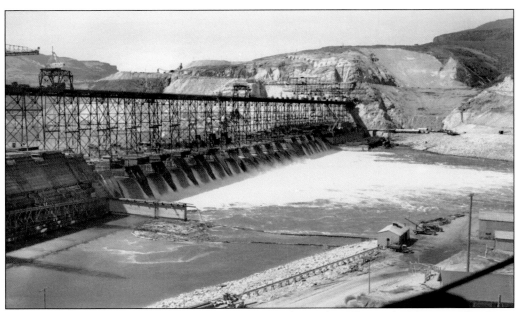

This view during a flood peak, about June 1, 1939, shows the CBI trestle spanning the entire dam with the Columbia River spilling through 15 of the openings between blocks. CBI built eight portable gates at 52 feet wide, 35 feet high, and weighing 75 tons and portable steel guides, allowing them to cut off water and pour 5-foot lifts of concrete between blocks in an alternating sequence. (Courtesy author.)

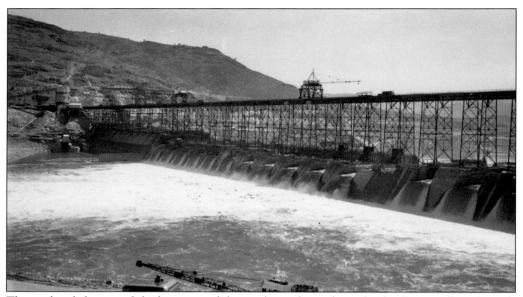

This undated photograph looking toward the southeast shows the Columbia River spilling through openings between blocks. Five of the openings in the middle of the river are slightly lower than the openings to either side. The enlarged east-side concrete mixing plant (Eastmix plant) is visible on the hill to the left. CBI employed over 5,500 workers in April 1939. (Courtesy author.)

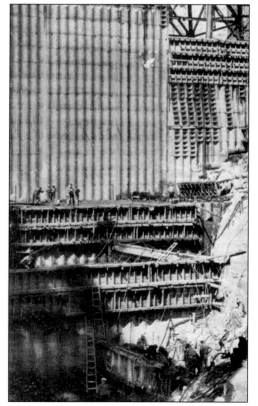

This undated photograph shows workmen on some of the slip forms used in the block pours. The slip forms were raised and oiled for each pour as the block grew in height. The large vertical V-shaped grooves in the concrete are shear keys, which help to interlock the blocks that make up the dam. On May 25, 1939, CBI poured a record 20,684.5 cubic yards of concrete in 24 hours. (Courtesy author.)

This scene shows work progressing on blocks within the east cofferdam, visible at the right. This photograph gives another view of shear keys, the large vertical V-shaped grooves that interlock adjacent blocks poured at different times. Various planks are suspended to provide access for workmen to complete their tasks. During September 1939, CBI poured over 400,000 cubic yards of concrete, followed by 536,264 cubic yards in October. (Courtesy author.)

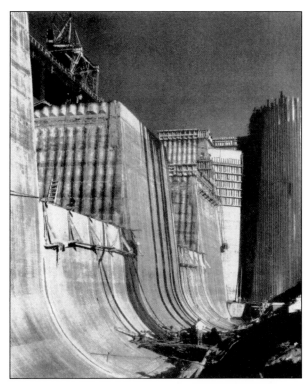

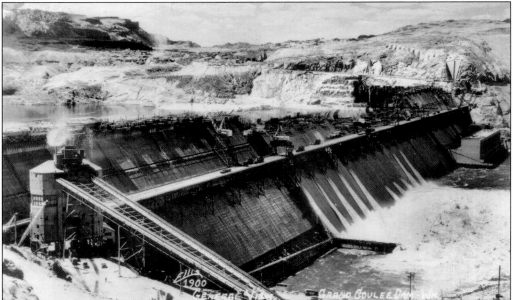

This undated photograph shows Grand Coulee Dam as it nears full height. Some of the whirley cranes are now mounted on special gantries rolling on one rail up on the dam and one rail on the trestle, and some are still on Clyde Wylie gantries. The 780-foot-long west powerhouse structure is nearly complete, and work on the wing dam and pumping station is under way. (Courtesy author.)

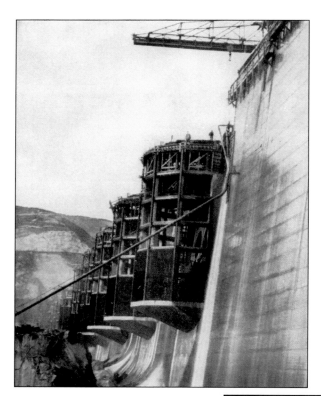

This undated view shows some of Grand Coulee Dam's heavy steel trash racks under construction while work continues on the top of the dam. These trash racks are mounted on reinforced concrete frames to protect the dam from debris. The large pipe in the foreground is equipped with a handrail and a ladder for workman access. (Courtesy author.)

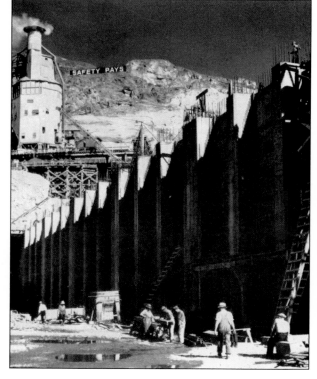

This view shows the east powerhouse base under construction with the Eastmix plant in the background. The workers are well below the level of the river, protected by a cofferdam. The large "Safety Pays" sign was added by MWAK early in the project, as accidents and fatalities began to occur at an alarming rate. (Courtesy author.)

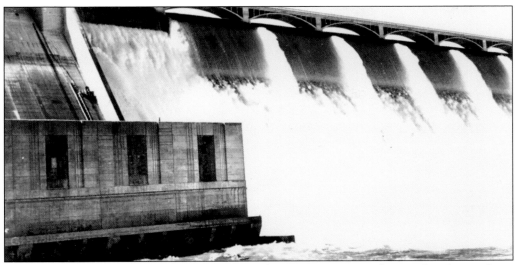

This undated photograph shows the east powerhouse structure nearly complete but with no generators on line, as the Columbia River passes over the spillway beneath the graceful reinforced concrete arch bridge that carries the roadway atop the dam. The pattern of lines on the powerhouse is typical of the dam's art deco styling. (Courtesy author.)

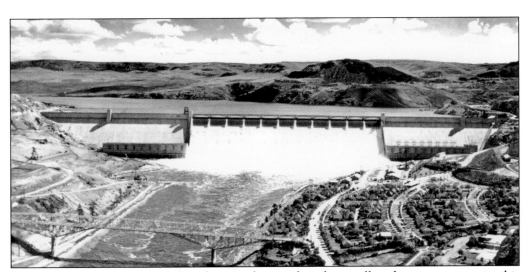

The east powerhouse at the left and its nearby switchyard are still under construction in this undated view. In 1942, Fred W. Nolte Jr. pulled a cable through 550 feet of partly clogged, 24-inch-diameter pipe by tying a strong cord to the collar of a cat, which was hazed with a blast of compressed air. The cord was then used to pull the cable through the pipe. (Courtesy author.)

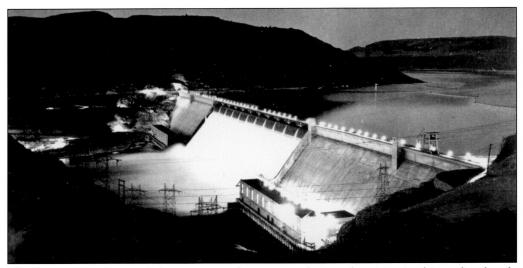

The dam is complete, and the west powerhouse is producing electricity in this undated early morning photograph looking toward the southeast. The east powerhouse is not yet online as evidenced by its dark windows and the lack of power lines leading from the roof to the dark site of the future east switchyard. CBI completed work on January 31, 1943, with the contract cost totaling $41,366,900. (Courtesy author.)

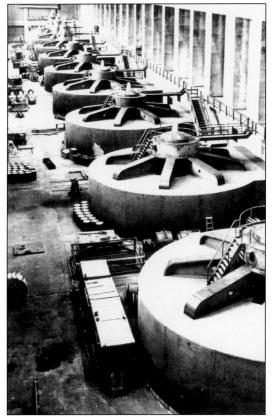

This undated photograph shows one of the powerhouses at Grand Coulee Dam with all nine generators in place but in varying degrees of completion. The dam's generators first went online in 1941, and all 18 were operational by 1950. Each generator was rated at 108,000 kilowatts and has been rewound to increase its rating to 125,000 kilowatts. (Courtesy author.)

# Four

# THE COMPLETED DAM

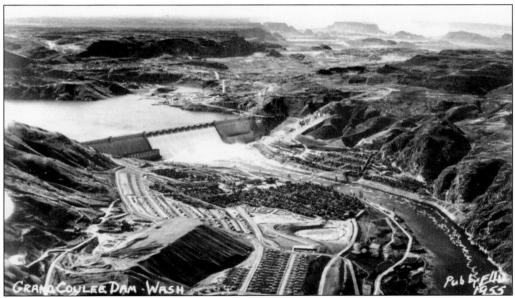

This aerial view shows the completed Grand Coulee Dam looking toward the southeast. The rugged Grand Coulee is visible in the upper right, with the town of Grand Coulee visible to the left of the coulee. The conveyors, temporary bridges, and concrete mixing plants have been removed, leaving the government highway bridge and the town of Coulee Dam, formerly Mason City, on the left and Engineer's Town on the right. The east powerhouse is visible at the left base of the dam, and the west powerhouse is visible at the right base of the dam. As World War II loomed closer, the government expedited completion of several of the dam's generators in anticipation of the need for electrical power. This power was put to work making aluminum for airplane production, powering shipbuilding, powering the production of atomic weapons at the top-secret Hanford Works about 130 miles to the south, and powering much more war production. (Courtesy author.)

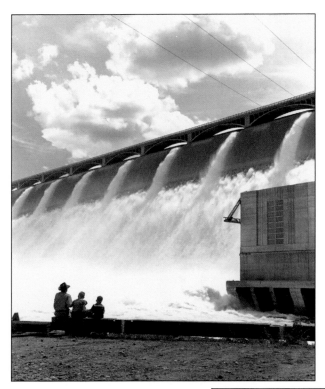

Three people in awe watch the Columbia River passing over Grand Coulee Dam's spillway in this undated photograph. The reinforced-concrete arch bridge atop the dam creates quite an aesthetic appearance for a structure containing a record 11,975,200 cubic yards of concrete. The corner of the west powerhouse is visible at the right with power lines overhead. (Courtesy Washington State Archives.)

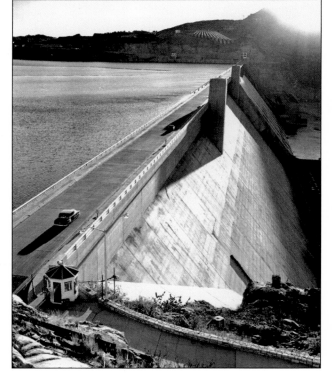

The massive size of Grand Coulee Dam is apparent in this photograph showing automobiles driving on the roadway on top of the dam. The top of the dam is 30 feet wide and 550 feet above bedrock, and construction of the dam required excavation of 20,535,422 cubic yards of earth, 2,095,557 cubic yards of rock, and 25 million cubic yards of sand and gravel. (Courtesy Washington State Archives.)

This photograph shows the 4,173-foot Grand Coulee Dam, with its pumping plant in the background at the west end of the dam. Six 1,600-cubic-foot-per-second-capacity pumps driven by 65,000-horsepower electric motors, 12-foot-diameter tubes 800 feet long, and a feeder canal carry the pumped water into the balancing reservoir located in the coulee. Steamboat Rock is visible in the left background. (Courtesy Washington State Archives.)

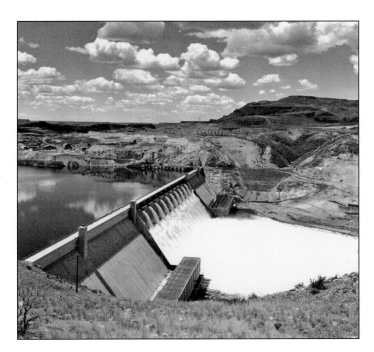

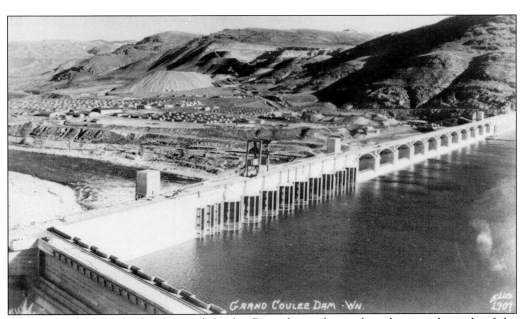

This view of the backside of Grand Coulee Dam shows the trash racks on either side of the 1,650-foot spillway. Above the spillway is the graceful 11-span, reinforced concrete, arch bridge, completed in five months in 1941, and under each span of the bridge is a drum gate 135 feet wide with a 28-foot rise. The wing dam at the lower left serves the pumping station for irrigation water. (Courtesy author.)

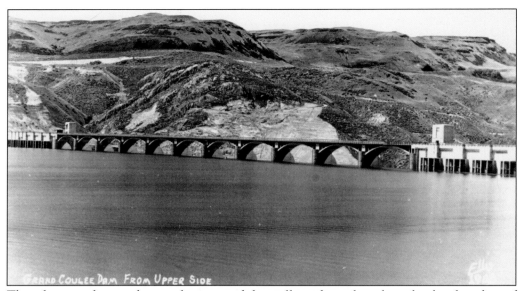

This photograph provides another view of the spillway from the relatively placid surface of Franklin D. Roosevelt Lake. Construction of the dam, which impounds 10 million acre-feet of water, consumed 11,975,200 cubic yards of concrete, 12 million barrels of cement, 19,000 tons of sheet piling, and 130 million board feet of timber used for cribbing, forms, temporary bridges, pilings, and many other uses. (Courtesy author.)

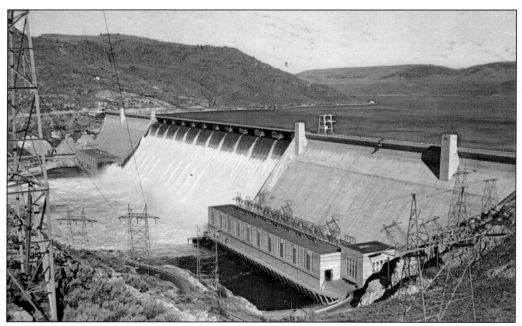

This undated photograph shows Grand Coulee Dam with its west powerhouse in the foreground. The west powerhouse contains nine generators rated at 108,000 kilowatts and three station service generators rated at 10,000 kilowatts. The lower portion of the 151-mile-long Franklin D. Roosevelt Lake is visible behind the dam. (Courtesy author.)

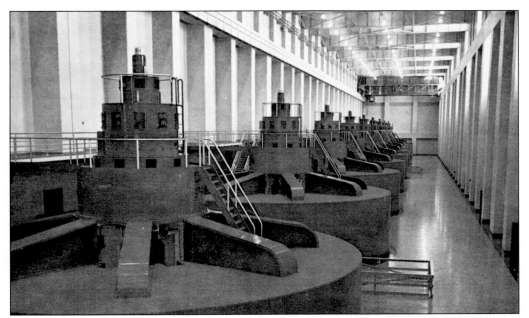

The interior of the east powerhouse is in impeccably clean condition in this photograph. All nine of the east powerhouse's generators are visible, each rated at 108,000 kilowatts. The first generators in the west powerhouse went online in 1941, and the last of the 18 power generators at the dam went online in 1950. (Courtesy author.)

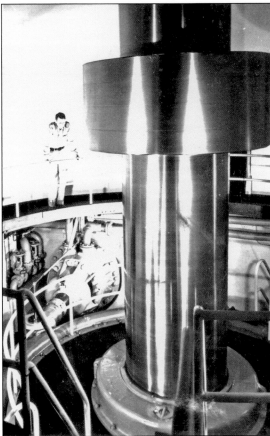

This photograph shows one of the 70-ton shafts that transmit power from the turbines to the generators. The dam's 150,000-horsepower turbines were manufactured by the Allis Chalmers Manufacturing Corporation, and were so large that they required special shipping crates and had to be routed on rail lines that could avoid routes with low overhead clearance or narrow bridges. (Courtesy author.)

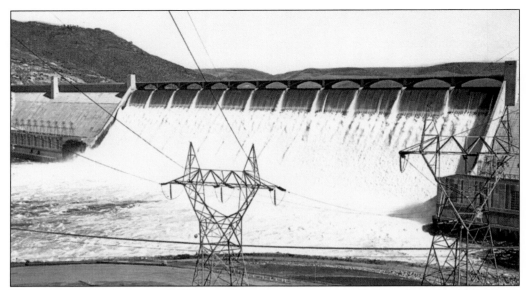

This photograph shows the 1,650-foot-wide spillway of Grand Coulee Dam and its graceful, reinforced-concrete arch bridge. In the foreground is a series of electric transmission lines that transmit the electric power to switchyards located high on the hills west of the dam. Grand Coulee Dam was designed and built as a gravity-type dam, which uses massive weight to resist overturning. (Courtesy Julie Albright.)

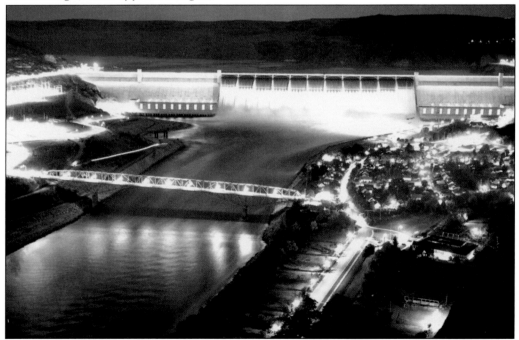

This photograph shows Grand Coulee Dam in twilight with lighting on. The spillway is illuminated by a multicolor lighting system for the benefit of tourists, the lights are on in the powerhouses, and street lighting is on in Coulee Dam. Even the highway bridge has street lighting. (Courtesy Washington State Archives.)

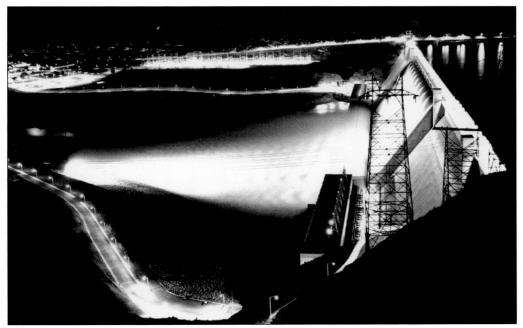

This night photograph also shows the multicolor lighting system aimed at the spillway of Grand Coulee Dam. The switchyard for the east powerhouse is well lit on the east side of the Columbia River, between the dam and the town of Coulee Dam, which is visible at the left. (Courtesy Washington State Archives.)

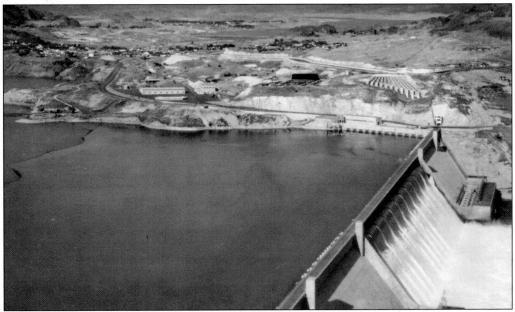

This view of Grand Coulee Dam looking toward the southwest shows the Grand Coulee Highway leading toward the town of Grand Coulee and into the coulee. At the west end of the dam is the wing dam and pumping plant, and a series of tubes are visible above the pumping plant, which carry water from the pumping plant to a canal that leads toward the coulee. (Courtesy author.)

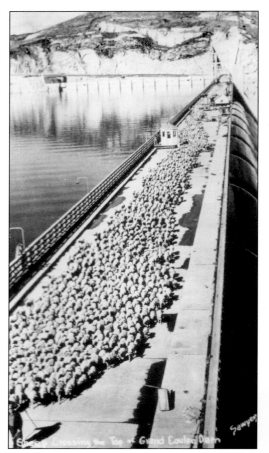

This 1943 photograph shows Adrian, Washington, wool grower Joe Hodgin moving a band of 2,600 sheep to summer grazing in the northern Washington forests, using the road on top of Grand Coulee Dam. The wooden bridge railings shown were replaced with aluminum railings after World War II. (Courtesy author.)

This photograph shows one of Grand Coulee Dam's many inspection tunnels. On March 14, 1952, what was termed by a Bureau if Reclamation engineer as an "improbable constellation" of events resulted in floodwaters entering some of these inspection tunnels. Workers managed to stop the flood before anyone was seriously hurt, and procedures and safeguards were put in place to prevent future "improbable constellations" of events. (Courtesy author.)

# *Five*

# IRRIGATION AND THE
# THIRD POWERHOUSE

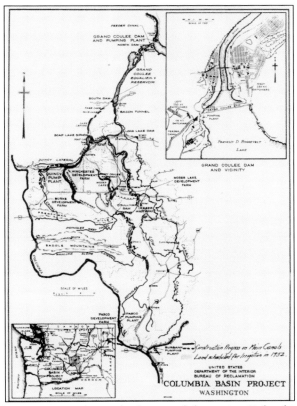

This Bureau of Reclamation map shows the layout of the entire Columbia Basin Project with canals completed before 1952 marked with solid lines, and canals scheduled to be ready for irrigation in 1952 marked with dashed lines. The balancing reservoir, Banks Lake, shown here as the equalizing reservoir, is contained by earthen dams at each end. A canal carries the water through the Bacon Tunnel south of Coulee City, feeding the East High Canal and Long Lake Dam. Long Lake Dam feeds the West Canal and the East Low Canal. The Potholes Dam, shown here as O'Sullivan Dam, was to be fed by a canal from the East Low Canal via Moses Lake. Pumping plants are shown at Quincy and Pasco, although the one at Pasco appears to be supplied directly from the Columbia River. Also shown are four development farms, which the bureau planned to operate as models of what could be accomplished with irrigation. The project eventually included 333 miles of mains, 1,993 miles of laterals, and 3,498 miles of drains, and wasteways. (Courtesy Washington State Archives.)

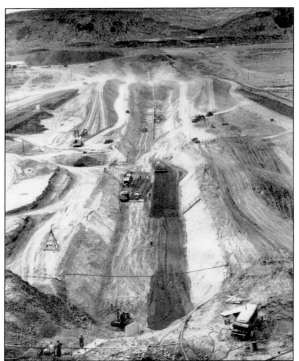

This photograph shows construction at the site of Long Lake Dam. The site was excavated to bedrock and filled with impervious clay around and over a concrete core wall, visible at the lower left. The core wall provides a backbone to key the earthen dam into the bedrock. (Courtesy Washington State Archives.)

This photograph shows construction at the site of Potholes Dam, which will cover a surface of 47 square miles. The heavy equipment shown is filling the main section of the earthen dam, with a farmer's cover-crop disk harrow pulled by a Caterpillar tractor working in the left foreground and a very large sheep's-foot roller being pushed and pulled by two tractors at the upper right. (Courtesy Washington State Archives.)

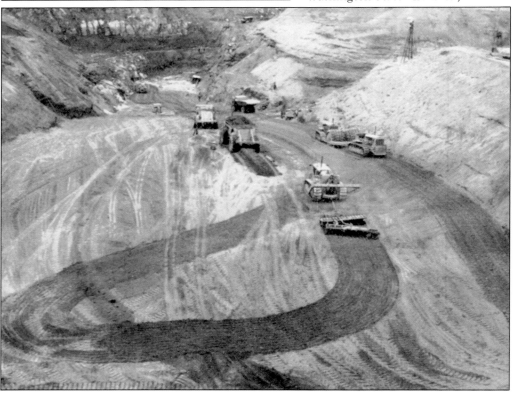

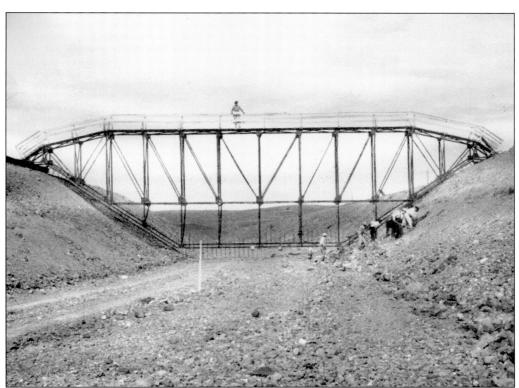

The West Canal is under construction in this photograph, which illustrates a machine known as a Whisker Jumbo. The machine rolled on rails placed at the top of the banks, and used steel "whiskers" to indicate the dimensions of the canal in preparation for lining the canal with concrete. (Courtesy Washington State Archives.)

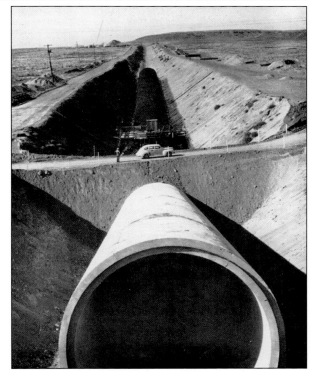

This September 24, 1947, photograph shows the Dry Coulee Siphon on the West Canal during a construction hiatus. The contractors, Winston Brothers and Utah Construction Company, with over $300,000 worth of specially designed equipment on site, were apparently unable to complete the project and abandoned the site. (Courtesy Washington State Archives.)

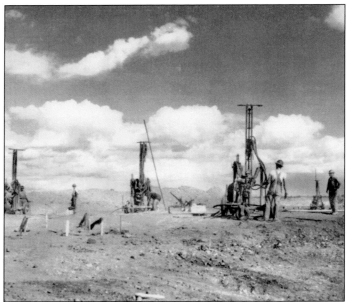

Wagon drills are drilling holes in bedrock for blasting on the route of the East Low Canal in this undated photograph. The drills appear to be powered by compressed air and are capable of drilling holes to the depth of the canal. The drill operators wear hard hats. (Courtesy Washington State Archives.)

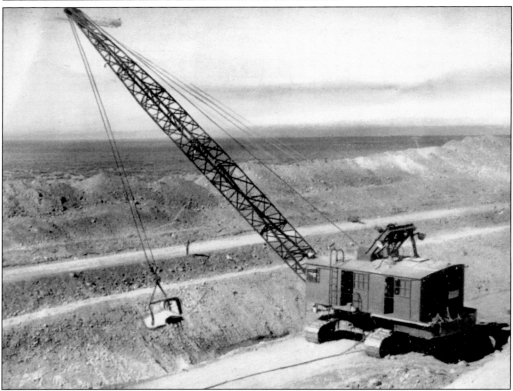

An electric dragline excavates during construction of the East Low Canal in this photograph. The East Low Canal was noted to be approximately the same size as the West Canal. Several electric lights mounted on the machine suggest that it was intended for at least occasional night operation. (Courtesy Washington State Archives.)

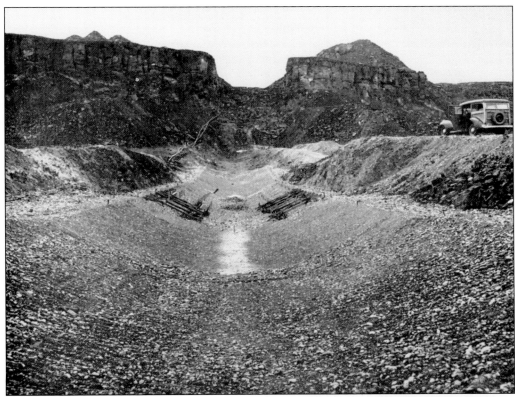

This September 9, 1947, photograph shows a partially completed canal looking toward the future site of the Bacon Tunnel. The contractor for this portion of the work, T. E. Connolly, apparently also abandoned the project. The abandonment was possibly related to the very rocky nature of the site. (Courtesy Washington State Archives.)

This September 9, 1947, photograph shows the outlet portal of the partially completed Bacon Tunnel. When completed, the Bacon Tunnel was 2 miles long, 23.3 feet in diameter, and was designed to carry 8,000 cubic feet of water per second. The steel rails, in poor repair, were used to carry out excavated rock. Pumps did not begin filling Banks Lake until May 7, 1951. (Courtesy Washington State Archives.)

This undated photograph shows a partial trailer load of corn grown in the Columbia Basin Project. One of the many crops grown on the irrigated lands of the Columbia Basin Project, corn was reported to yield over 100 bushels per acre. Irrigation using water from Grand Coulee Dam began in May 1951. (Courtesy Washington State Archives.)

This pear box label from Columbia Basin Orchard illustrates the variety of crops that used Columbia Basin Project water. Farmers within the project faced several obstacles, including Bureau of Reclamation acreage limits and an initial cost of $80 per acre. The acreage restrictions became even more problematic but were eventually relaxed, as farm sizes throughout the U.S. grew. (Courtesy author.)

Electrification transformed rural life in many ways, including lighting, water pumping, refrigeration, cooking, laundry, and many farm chores that could be lightened by electric motors. This photograph shows a milk house with refrigeration. The ability to easily keep perishable foods cold has prevented a great deal of waste and saved many lives. (Courtesy Washington State Archives.)

Workmen are placing one of 28 massive coupling bolts into a turbine runner in this photograph taken in the third powerhouse on December 3, 1974. Each of these special bolts is nearly 58 inches long and weighs 1,000 pounds. This part of the work is being completed by contractor Bingham-Willamette. (Courtesy author.)

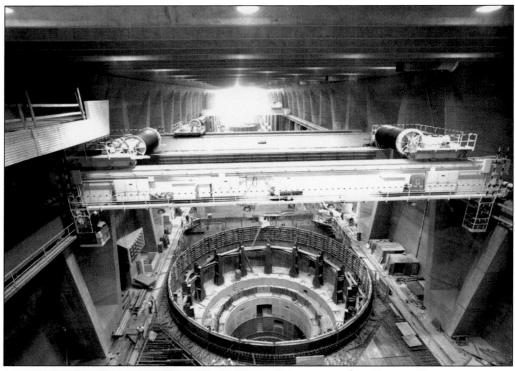

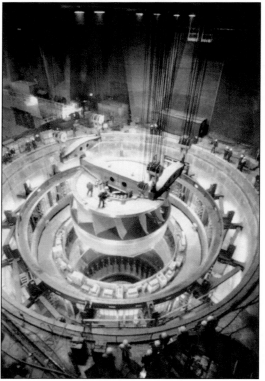

Preparations for a "top out" concrete pour in the third powerhouse are shown in this August 7, 1975, photograph. This view shows work on Unit No. 21, a 600,000-kilowatt generator, being completed by contractor Vinnell-Dravo-Lockheed-Mannix. The third powerhouse contains three 600,000-kilowatt Westinghouse generators and three 700,000-kilowatt Canadian General Electric generators. The Ederer 275-ton overhead crane was surely put to good use. (Courtesy author.)

This undated photograph shows several workmen riding on a turbine as cranes lower it into place in Grand Coulee Dam's third powerhouse. Some of the 28 coupling bolts shown on page 123 are visible below. The third powerhouse's generators have a diameter of 68 feet and weigh 1,900 tons. As of 1985, the cost of the third powerhouse totaled $668,000,000. (Courtesy Bureau of Reclamation.)

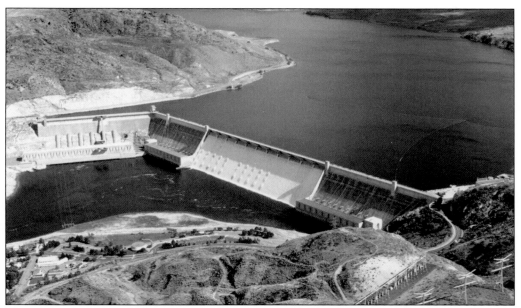

This undated view shows Grand Coulee Dam with the third power plant to the left. Construction of the third powerhouse was authorized in 1966; its last generator was commissioned in 1980, and the third powerhouse added 4,215,000 kilowatts of rated generator capacity. The dam, now 5,223 feet long, can produce up to 23,860,944,469 kilowatt-hours of electric power each year with generating capacity of 6,494,000 kilowatts. (Courtesy Bureau of Reclamation.)

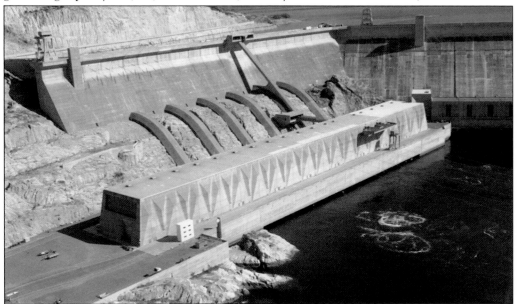

This undated photograph shows the third power plant with the forebay dam and third powerhouse added. The east end of the original dam was removed to block 92, and the forebay dam seen here was built. Streamlined styling was used on the third powerhouse and forebay dam to provide a modern appearance somewhat compatible with the original dam and powerhouses' art deco styling with massive lines. (Courtesy Bureau of Reclamation.)

# BIBLIOGRAPHY

Caterpillar Tractor Company. *Fifty Years on Tracks*. Peoria, IL: Caterpillar Tractor Company, 1954.

Crimson, Frederick W. *International Trucks*. Osceola, WI: Motorbooks International Publishers and Wholesalers, 1995.

Dill, Clarence C. *Where Water Falls*. Spokane, WA: Self-published, 1970.

Downs, L. Vaughn. *The Mightiest of Them All: Memories of Grand Coulee Dam*. New York: ASCE Press, 1993.

http://en.wikipedia.org/wiki/Grand_Coulee_Dam

Ficken, Robert E. *Rufus Woods: The Columbia River, & The Building of Modern Washington*. Pullman, WA: Washington State UP, 1995.

*Grand Coulee Dam and Columbia Basin Irrigation Project*. Spokane, WA: Shaw and Borden, 1936.

Grand Coulee Dam Bicentennial Association. *From Pioneers to Power, Historical Sketches of the Grand Coulee Dam Area*. Nespelem, WA: Rima Printing and Graphics, 1976.

*Grand Coulee Dam Facts and Columbia Basin Irrigation, Briefly Stated for Busy Folks*. Coulee Dam, WA: Columbia Souvenirs, 1946.

*Grand Coulee Dam, The Eighth Wonder of the World*. Davenport, WA: Times Publishing Co., 1947.

Holstine, Craig E, and Richard Hobbs. *Spanning Washington, Historic Highway Bridges of the Evergreen State*. Pullman, WA: Washington State UP, 2005.

Irish, Kerry E. *Clarence C. Dill, The Life of a Western Politician*. Pullman, WA: Washington State UP, 2000.

Jones, Nard . *Still to the West*. New York: Dodd, Mead and Company, 1946.

Letourneau, P. A. *Caterpillar Sixty Photo Archive*. Minneapolis: Iconografix, 1993.

Library of Congress, Historic American Engineering Record, National Park Service, U.S. Department of the Interior, *Grand Coulee Dam Records*.

McGregor, Alexander Campbell. *Counting Sheet, From Open Range to Agribusiness on the Columbia Plateau*. Seattle: University of Washington Press, 1982.

McMacken, Joseph G. *Geology of the Grand Coulee, Third Edition*. Spokane, WA: Self-published, 1937.

———. *Grand Coulee of Washington, the Grand Coulee Dam in Picture and Story, Fifth Edition*. Spokane, WA: Self-published, 1942.

Morgan, Murray. *The Dam*. New York: Viking Press, 1954.

Nash, Bruce, and Allan Zullo. *Amazing But True Cat Tales*. Kansas City, MO: Andrews and McMeel, 1993.

Pitzer, Paul C. *Grand Coulee: Harnessing a Dream*. Pullman, WA: Washington State UP, 1994.

Ruby, Robert H., and John A. Brown. *Ferryboats on the Columbia River*. Seattle: Superior Publishing Co., 1974.

Sundborg, George. *Hail Columbia, The Thirty-Year Struggle For Grand Coulee Dam.* New York: Macmillan Company, 1954.

U.S. Department of the Interior, Bureau of Reclamation. *The Grand Coulee Dam and the Columbia Basin Reclamation Project.* U.S. Government Printing Office, Publication Number 6-9781.

————. *Grand Coulee Dam, The Columbia Basin Reclamation Project.* U.S. Government Printing Office, Publication Number 6-9650.

————. *The Grand Coulee Dam and the Columbia Basin Reclamation Project.* U.S. Government Printing Office, Publication Number 65486°-36.

Warth, Thomas E. *Mack AP Super-Duty Trucks, 1926–1938 Photo Archive.* Osceola, WI: Iconografix, 1996.

www.co.sheridan.mt.us/homesteadlaws.htm

www.gepower.com/about/press/en/2003_press/052603.htm

www.usbr.gov/power/data/sites/grandcou/grandcou.html

www.wshs.org/wshs/columbia/articles/0301-a3.htm

Young, James A., and Jerry Budy. *Endless Tracks in the Woods.* Osceola, WI: Motorbooks International Publishers and Wholesalers, 1993.

# Discover Thousands of Local History Books
## Featuring Millions of Vintage Images

Arcadia Publishing, the leading local history publisher in the United States, is committed to making history accessible and meaningful through publishing books that celebrate and preserve the heritage of America's people and places.

Find more books like this at
**www.arcadiapublishing.com**

Search for your hometown history, your old stomping grounds, and even your favorite sports team.

Consistent with our mission to preserve history on a local level, this book was printed in South Carolina on American-made paper and manufactured entirely in the United States. Products carrying the accredited Forest Stewardship Council (FSC) label are printed on 100 percent FSC-certified paper.

**MADE IN THE USA**